THE
Archive Photographs
SERIES
BISHOPSTON
HORFIELD AND
ASHLEY DOWN

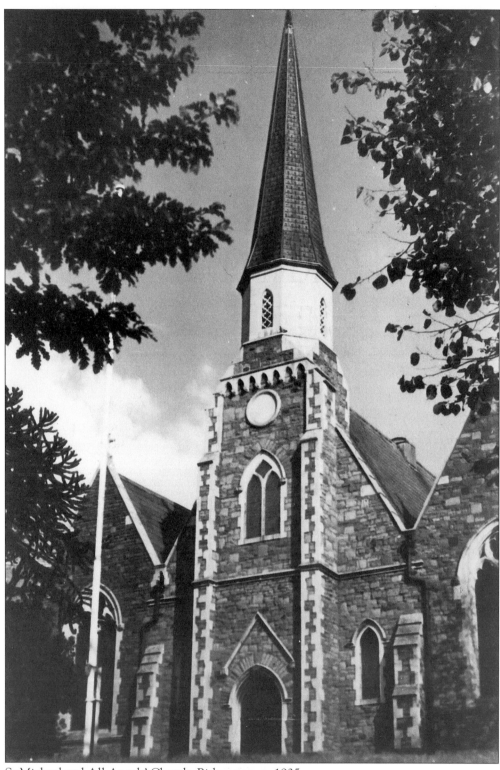

St Michael and All Angels' Church, Bishopston, *c.* 1935.

THE
Archive Photographs
SERIES

BISHOPSTON HORFIELD AND ASHLEY DOWN

Compiled by
Brian Amesbury
Diana & John Davis
Ken Forward, Penny Jetzer
Pat Smith, Molly Snart,
Geoff Rosling and
Richard Webber

CHALFORD

First published 1997
Copyright © Brian Amesbury, Diana & John Davis, Ken Forward, Penny
Jetzer, Pat Smith, Molly Snart, Geoff Rosling, and Richard Webber, 1997

The Chalford Publishing Company
St Mary's Mill, Chalford,
Stroud, Gloucestershire, GL6 8NX

ISBN 0 7524 1057 1

Typesetting and origination by
The Chalford Publishing Company
Printed in Great Britain by
Bailey Print, Dursley, Gloucestershire

Contents

Acknowledgements

We would like to thank the following for supplying photographs and information for this book: Mrs M.W. Adams, Mrs J. Allen, Mr and Mrs R. Aubrey, Jane Baker, Miss D. Barton, G. Bennett, The *Bristol Evening Post*, *Bristol the Growing City* (David Harrison), City of Bristol Library Service (Loxton drawings), Andy Buchan, Amy Cameron, Pete Clements, Mrs P. Clifford, Mrs J. Cox, Peter Davey, Jean and Brian Fenn, Janet and Derek Fisher, Mr and Mrs Ken Forward, Robert Gilbert, Gloucestershire County Cricket Club, the late Norah Gover, Jill Groves; Laurie Hall, Linda Hall, the late Ellen Hallett, Peter Harris (Bristol Historical Association), Pastor K.A. Harris, D. Hiles, Horfield Baptist Church, Margaret Humphries; T.J.D. Jeffrey, Penny Jetzer, Harold Lane of Frampton Cottrell, Phyl Lewis, Mr and Mrs D. Nicholls, Mrs M. Owen, Andrew Palmer, Edna Petit, Beryl Philpott, Jill Pugh, Brenda Rose, Geoff Rosling, Gwenyth Sage, Mrs S. Shelley, Patricia Smith, Mr Stephenson, B. Stirratt, St Bonaventure's Archive, Miss E. Thomas, Mrs A. Threader, the late Ron Tippetts, Mike Tozer, The *Western Daily Press*, S. White.

Authors' note

The boundaries of Bishopston, Horfield, and Ashley Down are very difficult to define and vary according to whether you follow the postal districts, district boundaries, or parliamentary boundaries. Borders were originally created by streams such as the brook running down alongside Cranbrook Road (from which the latter derives its name) which forms part of the division between Bishopston and Redland. Another such stream is that running along North Road behind Gloucester Road to form the eastern boundary of Bishopston. Roads can also form boundaries and that between Bishopston and Horfield is a line down the middle of Longmead Avenue with Bishopston to the south and Horfield to the north. Nevil Road is another part of the boundary between Bishopston and Horfield, but here it becomes complicated by the presence of Ashley Down, a district which came from the name of the road connecting Horfield and Ashley Down, and the actual boundary is not very clear. Some of the roads around the County Ground might equally belong to Bishopston, Ashley Down, Horfield, or St Andrew's according to traditional usage, and all fall in the postal district of BS7.

St Andrew's is another district which was originally part of Bishopston but now has its own church of St Bartholomew after the closure of St Andrew's Church, Montpelier. Cromwell Road forms part of the boundary between Bishopston and St Andrew's and then runs into Ashley Down where it crosses Chesterfield Road.

Horfield was taken over by other districts in the late Thirties and the Fifties when Henleaze and Manor Farm were developed. All the area to the north-west of Golden Hill, which was once part of Horfield, is now Henleaze, and Manor Farm has become Westbury on Trym for postal purposes, although geographically it is still very much part of Horfield. The major part of Filton Avenue is still in Horfield according to the postcode, as is Muller Road (shown on the 1910 street map as Lockleaze Road). Muller Road was not built until about 1921. The eastern boundary of Horfield is most probably a line drawn along the back of the properties in Brynland Avenue and Gloucester Road then crossing Ashley Down Road at Downend Road and through to Dovercourt Road, Lockleaze Road, and alongside the railway line.

One

Bishopston

Bishopston is a suburb extending either side of the Gloucester Road and contains land which had been owned by the manor of Horfield, an area over which the Bishop of Gloucester and Bristol had almost feudal rights. The suburb also included parts of Stapleton parish and part of the outer St Paul's parish. Kingsdown, Cotham, and Redland were developed in the nineteenth century and the adjacent open fields of the parish of Horfield attracted the attention of dev-elopers. From this came an interesting religious controversy involving Dr James Monk, Bishop of Gloucester and Bristol. Dr Monk offered to sell his interest in the land for £11,587, on condition that half the proceeds went to his family and the other half to poor parsons. The situation became very complicated and questions were asked in Parliament over the legal rights of the bishop's holdings. Any immediate development of the area was brought to a halt and could only be recommenced when a satisfactory conclusion had been reached.

The largest local copyholder was Rev Henry Richards, Vicar of Horfield. He became interested in the £545 annual income from the manor. Bishop Monk stated that Richards had tried to negotiate a lease for the manor, effectively making himself lord of the manor and recipient of the £545 per annum. Richards, for his part, said that Dr Monk had no right to actually sell the Horfield lease. Eventually, however, Dr Monk was recognised as the leaseholder and in 1858 a board of trustees took over the administration. The Bishop Monk Trust still exists and now receives ground rent from many local householders – Bishopston has a Bishop Road and a Monk Road, and of course the name Bishopston; we also have Monk's Park in Horfield.

Revd Richards later built a church at his own expense on Pigsty Hill on Gloucester Road. This was originally consecrated in 1862 and, dedicated to St Michael and All Angels, it became the parish church of the new area of Bishopston.

The original settlement of Bishopston centred round what is now Denmark

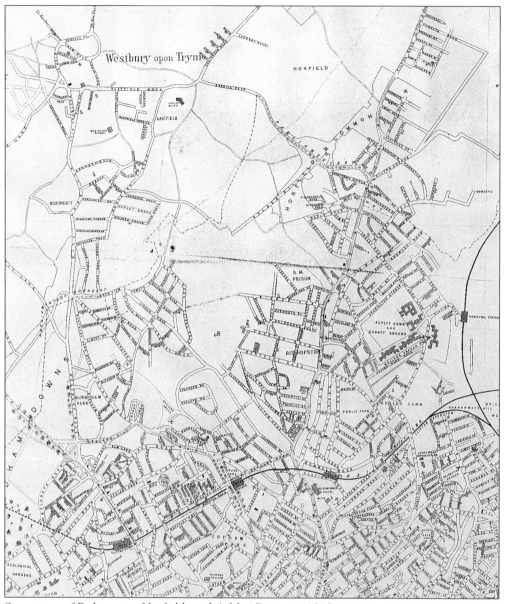

Street map of Bishopston, Horfield, and Ashley Down, *c.* 1910.

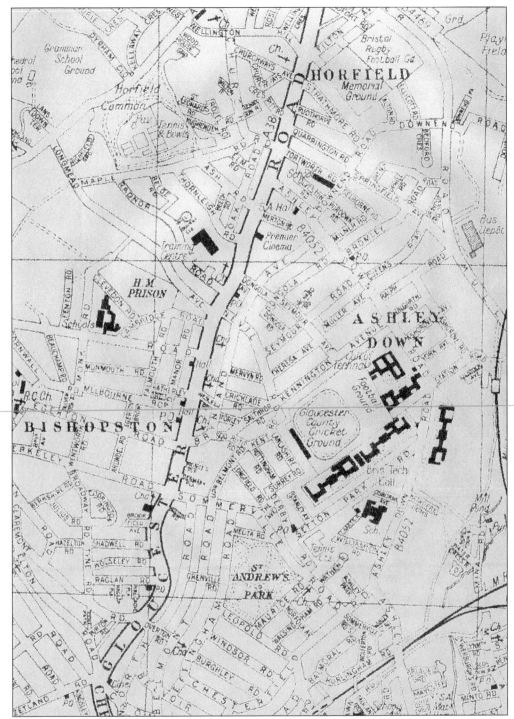

Street map of Bishopston, Horfield and Ashley Down, *c*. 1950.

Place, followed by Princes Place which was built by Alfred Hartnell. (Members of his family still live in the locality.) Near this point are 213–219 Gloucester Road, originally known as Alexandra Villas; these properties were built at the time of the marriage of the future Edward VII and Princess Alexandra of Denmark in 1863 and proved to be the beginning of Bishopston's housing development.

Egerton Road and Berkeley Road were built on the orchards of the Shadwell estate. These houses are very diverse in elevation, and many have long gardens containing fruit trees. Many of the new houses were occupied by business people moving out from the centre of Bristol, particularly the larger ones such as Morley Square, and by 1903 the population had grown sufficiently for the police station in Sommerville Road to be built.

In the early 1890s Wade's Cottages and yard were at the end of Dongola Avenue, but otherwise habitation here was sparse. In 1895, Mervyn Herbert Nevil Storey Maskelyne MP sold farmland for development to George Tyler of Brynland Avenue. Other landowners in the area were John H. Greville Smyth and Rev Dreyson Moor (Russell's Fields).

By the 1920s and 1930s there was little vacant land for building except for Longmead Avenue, and Radnor Road. After the Second World War when families became smaller and professional people left the area, houses were frequently converted to flats. There are no open areas in Bishopston except Morley Square. During the Second World War this area was covered with static water tanks (for combating fires), later removed by Mr Watts, who financed the operation by collecting £10 from each of the residents.

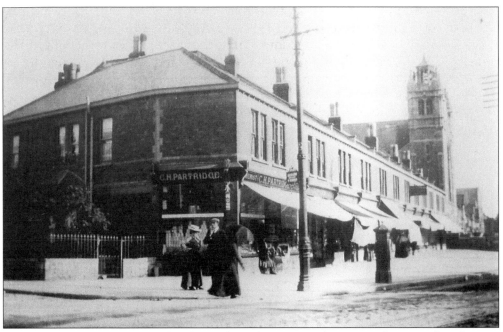

The corner of Gloucester Road and Nevil Road, *c.* 1907. The corner shop is still a chemists shop, now owned by Derek Walter. Horfield Baptist church can be seen in the distance.

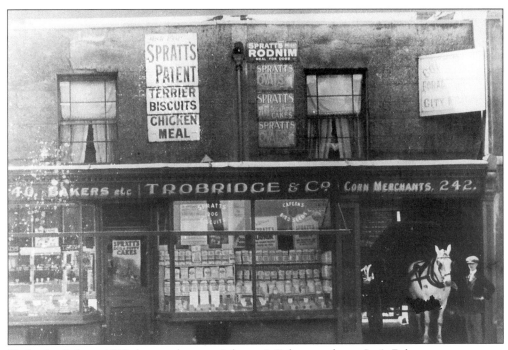

Trobridge Bakers, 1920, later to become Johnson's Bakers, and now Joe's Bakery.

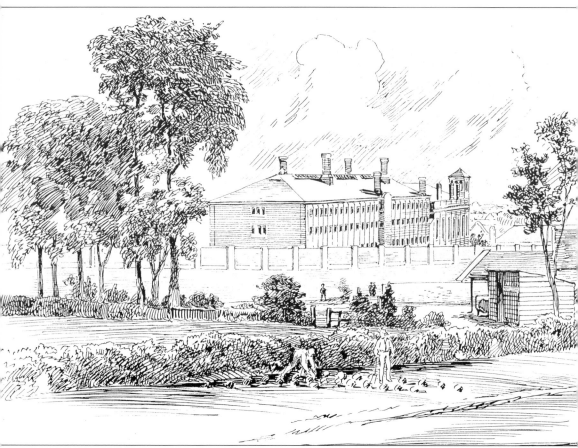

Loxton drawing, *c*. 1890. Horfield Prison stands on what was at one time a recreational park, some eight acres in extent, laid out as a profit-making venture by the Bristol Pleasure Gardens Company in 1861; the land had been sold to the company by Rev Henry Richards. The gardens were officially opened on 25 August 1862, with some 14,000 people present. However, they were not a commercial success and in February 1873 the company sold the gardens and they then became known as the Guernsey Gardens. Unfortunately, things did not improve and only six months later the land was sold to the Bristol Corporation who were looking for a suitable site for a new prison. At that time the site lay well outside, but conveniently adjacent to, the built-up limits of the City. The purchase price was £3,875, while the cost of constructing the new prison was estimated at £120,000 – an amount which caused a local outcry.

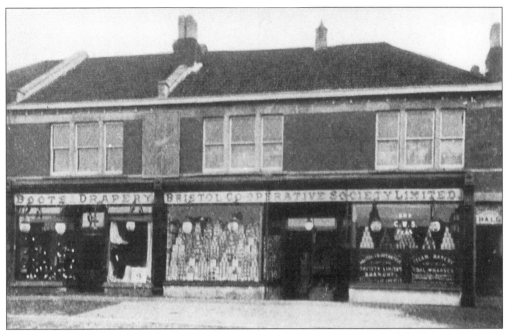

Gloucester Road branch of the Bristol Co-operative Society, next to Horfield Baptist Church, *c*. 1910. The Co-op have continued on this site to the present-day.

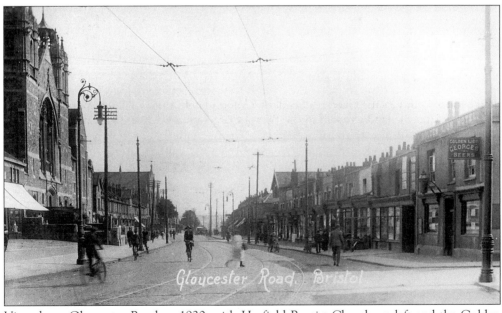

View down Gloucester Road, *c*. 1920, with Horfield Baptist Church on left and the Golden Lion public house (now renamed 'Finnegans Wake') on the right. Note the cyclist riding on the wrong side of the road!

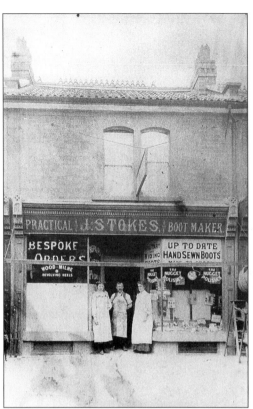

J. Stokes, practical bootmaker, 190 Gloucester Road. This is typical of the small businesses which flourished around the turn of the century.

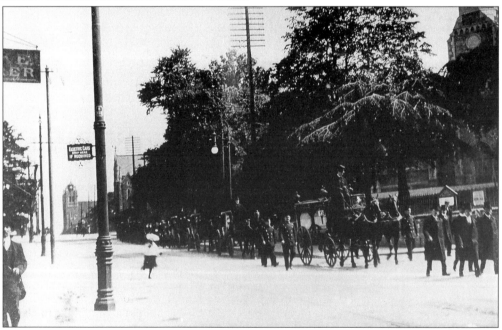

Funeral procession on Pigsty Hill, *c.* 1915. This short section of Gloucester Road is said to have got its name from a smallholding with a pigsty, situated where the present 'One in eight' voluntary project now stands.

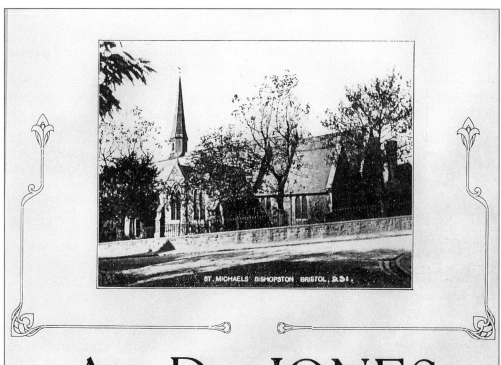

ST. MICHAELS BISHOPSTON BRISTOL, 231.

A. D. JONES

Manor Farm Dairy

259 Gloucester Road :: Bishopston

YOUR MILK SUPPLY

Should receive your utmost care and its purity be un-doubted.

We ask you for a trial and our quality will secure your permanent custom.

New Laid Eggs, Fresh Butter, and Pure New Milk
DIRECT FROM THE FARM.

Devonshire and Raw Cream Fresh Daily.

Farmhouse and Dairy Butter, Guaranteed Pure, at Moderate Prices.

13

Advertisement for Manor Farm Dairy from the *Bishopston Parish Magazine*, May 1952. The illustration of the church is from a picture taken in 1938. The railings around the churchyard were removed during the Second World War.

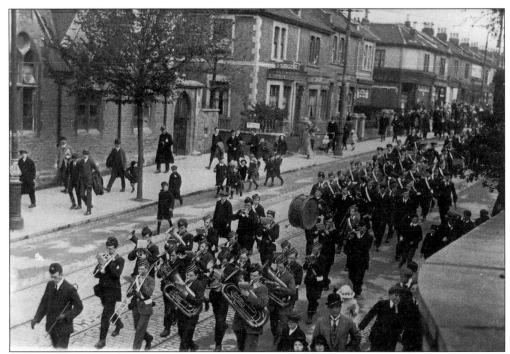

Boys' Brigade band marching down Pigsty Hill, *c. 1925*. The houses above the church hall have since been converted into shops.

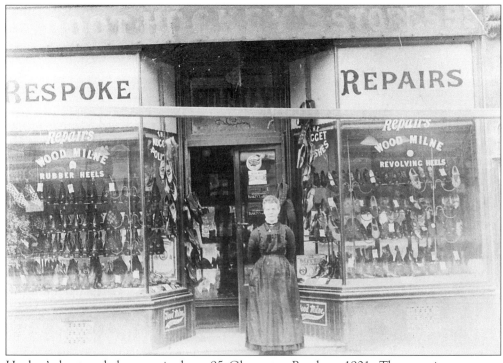

Hockey's boot and shoe repair shop, 95 Gloucester Road, *c. 1901*. The premises are now occupied by the St Peter's Hospice shop.

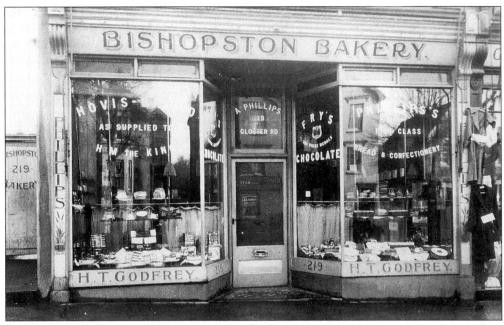

H.T. Godfrey, Bishopston Bakery (now B. & H. Tile Market), 219 Gloucester Road, *c.* 1930.

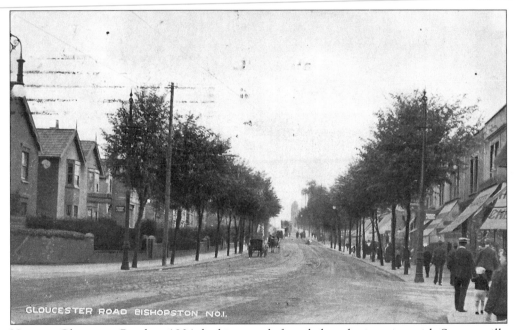

View up Gloucester Road, *c.* 1904, looking north from below the junction with Sommerville Road on the right, and Berkeley Road on the left. Hodders the chemist is on the corner of Sommerville Road, right foreground.

Advertisement from the *Bishopston Parish Magazine*, May 1952.

Part of advertisement page from the *Bishopston Parish Magazine*, May 1952.

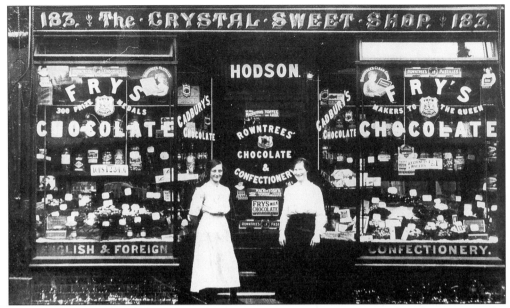

Crystal sweet shop, 183 Gloucester Road, Bishopston, *c*. 1905. This later became May's, and is still a newsagent's and confectioner's.

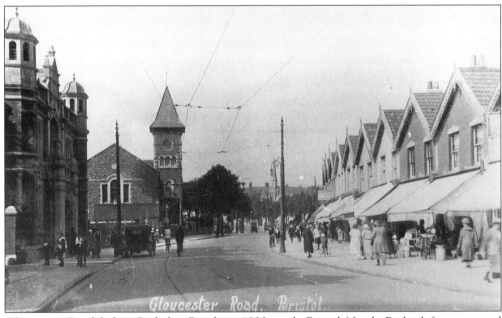

Gloucester Road below Berkeley Road, *c*. 1920, with Bristol North Baths left centre and Bishopston Methodist Church beyond. Note the tramway lines and overhead wires.

Advertisement page from the *Bishopston Parish Magazine*, November 1951.

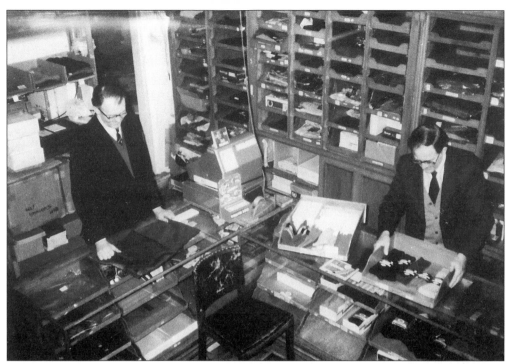

Laurie Hall and George Warburton in the shop of James T. Hall & Son, at 181 Gloucester Road, 1984, just prior to the closing of the shop.

Advertisement for local businesses from the *Bishopston Parish Year Book,* 1951.

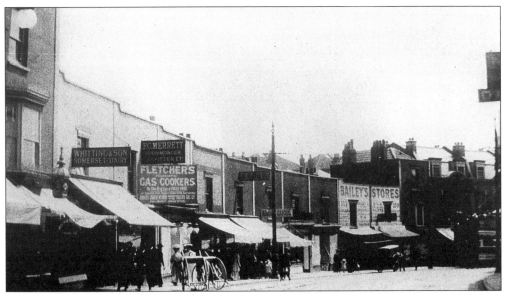

Gloucester Road, *c.* 1920, near the junction with Wolseley Road, which was named after 1st Viscount Field Marshal Garnet Wolseley (1833–1913), who fought in the Crimean War, against the Indian Mutiny, and led the expedition to rescue Gordon in Khartoum. Shops in this picture include Hawker's chemist's shop; Whitting, dairy; Merrett, ironmonger; Hill, fruiterer; Singer sewing machines; Goss, draper; Crouch, tobacconist; Bailey's Stores.

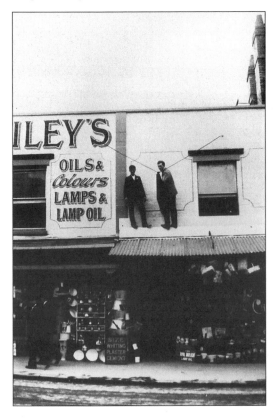

Workmen fixing the sign above one of Bailey's shops.

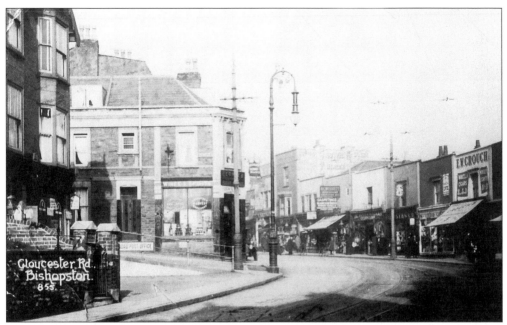

Gloucester Road looking north, c. 1920, from below the junction with Raglan Road, which was named after Lord Raglan, the famous, albeit much-criticised, British commander in the Crimean War.

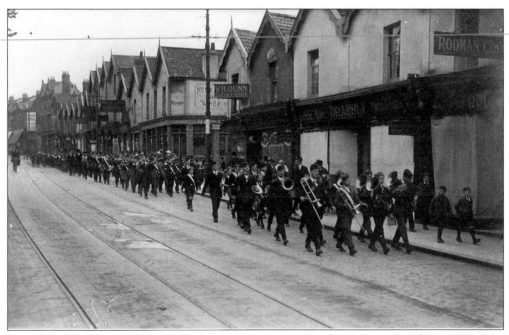

Marching band in Gloucester Road near the junction with Overton Road, c. 1920. The Foresters Arms public house is still in existence. Also in the picture are the Royal Hotel (now renamed the Hobgoblin) on the corner of Overton Road, H. Dunn's tobacconist on the opposite corner, Hallet's confectioner's, and a double-fronted shop later to become F.W. Allen's gramophone and record shop.

MANN

Baby Carriages & Push Cars

REPAIRS OF ALL KINDS PROMPTLY EXECUTED	PRAM WHEELS RE-TYRED PRAM HOODS RECOVERED PRAM APRONS FITTED

■ ■ ■ ■ ■ ■

THIS IS A CAR THERE IS A GREAT DEMAND FOR

■ ■ ■ ■ ■ ■

UP-TO-DATE IN STYLE AND PRICE

■ ■ ■ ■ ■ ■

Coach Made Body of the Best Birch 3-ply Wood, Panelled ——out as Designed, Coach Painted in any Colour——

WON'T THE KIDDIES BE PLEASED!

DOLLS' PRAMS

FROM THE WORLD'S CHEAPEST TO THE WORLD'S BEST

THEY LOOK GOOD AND ARE GOOD! DON'T BE LATE!
GET YOUR SHARE OF THE DEMAND!

AT MANN'S

54 Gloucester Road, . . Bishopston, Bristol

Full-page advert for Mann's pram shop, 54 Gloucester Road, from *Bishopston Parish Year Book* of 1951.

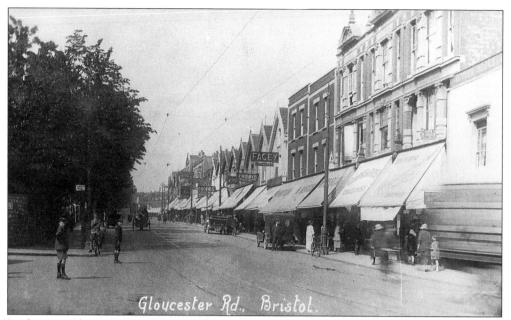

Looking up Gloucester Road from Zetland Road, *c.* 1925. Many of the shops in this section can be easily identified by their signs, no longer permitted under present bylaws. These shops were originally private homes and some of them bear the date of their construction, e.g. 1863.

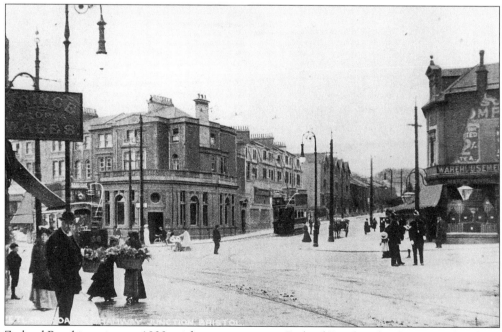

Zetland Road junction, *c.* 1932, with a tram going up Zetland Road in the direction of Cotham Grove and tram No 58 just entering Cheltenham Road.

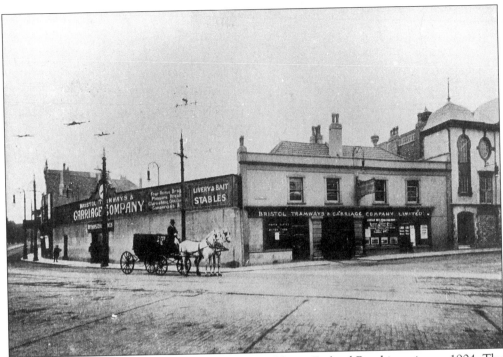

Bristol Tramways & Carriage Company's livery stables at Zetland Road junction, *c*.1904. The site was later rebuilt as Morgan's department store (*see opposite*).

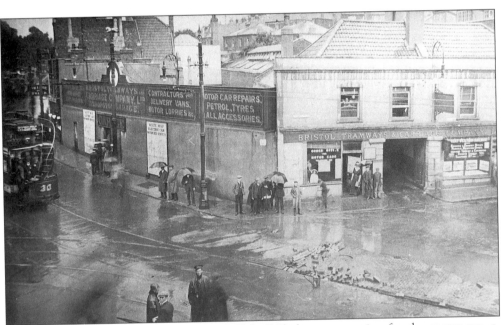

Bristol Tramways & Carriage Company (BT & CC), by now catering for the motor car, *c*. 1920. Flooding was caused by the Cran brook running down between Cranbrook Road and Elton Road having overflowed. This stream can still be seen near the junction of Elton Road and Claremont Road.

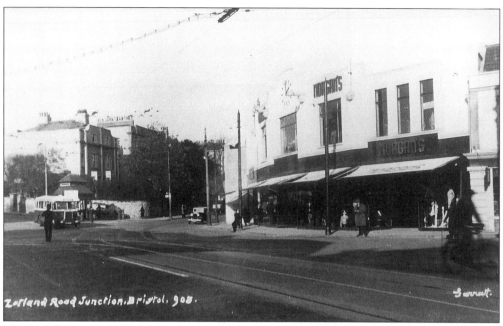

Morgan's Stores, *c.* 1935, later to become Colmer's, then Home Plan Furnishers and eventually Cash Converters.

HARTLEYS
—— *MAKE* ——

:: GOOD BREAD and CONFECTIONERY ::

BISHOPSTON, STAPLETON and FILTON
PHONE 45193

MORGAN'S
for VALUE
COURTESY
SERVICE •

BRISTOL'S
LEADING
STORE •

W. MORGAN (BRISTOL) LTD PHONE 45546. BISHOPSTON, BRISTOL, 7.

Advertisement for Morgan's Stores from the *Bishopston Parish Magazine*, November 1951.

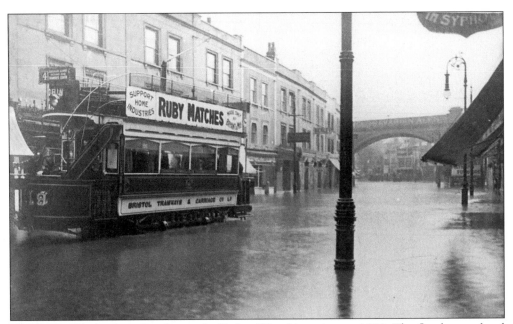

Flooding in Cheltenham Road near the Zetland Road junction, *c.* 1922. The flood-water level would appear to be about twelve inches.

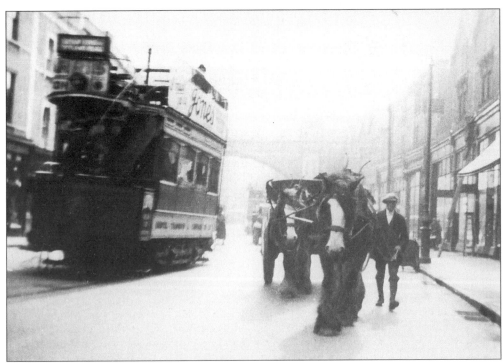

A tram-car passing a horse-drawn coal wagon in Cheltenham Road, *c.* 1921.

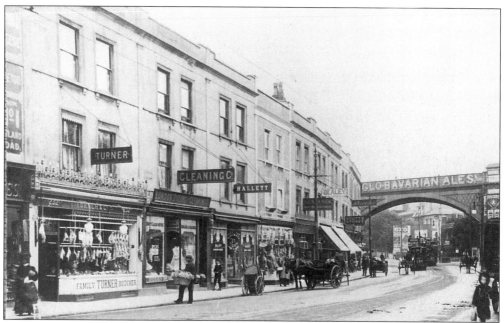

Cheltenham Road, *c.* 1922, showing a variety of shops, most with prominent signs. Note the horse-and-cart delivery system and tram-cars passing beneath the railway arches.

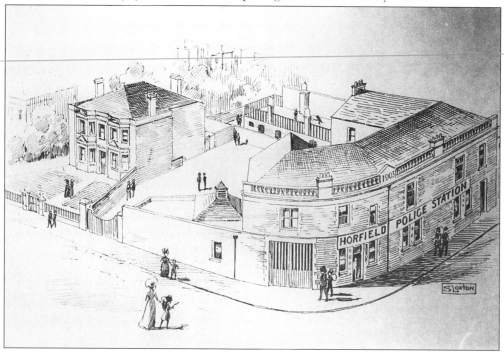

Loxton drawing of Sommerville Road police station, *c.* 1904. This was opened on 31 October 1903 and was built by Messrs R. Wilkins & Son at a cost of £4,437. It also incorporated a fire station with stables and a fodder store. The inspector occupied a house adjacent to the station-yard in North Road. In the years leading up to its closure *c.* 1967 Traffic Superintendent Sims resided there.

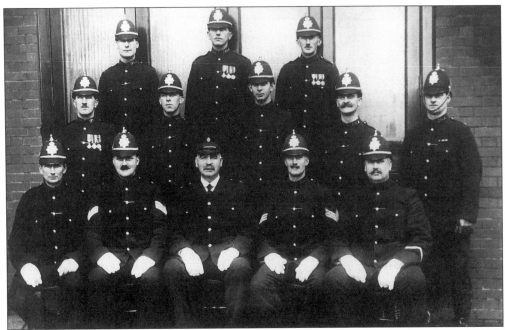

Inspector, sergeants, and police constables at Sommerville Road police station on the corner of North Road, *c.* 1910.

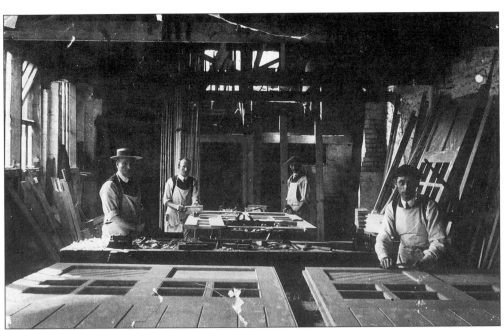

Interior of old workshop at S.W. Redwood & Son, builders, Sommerville Road, *c.* 1930. Redwood & Son, who were originally founded in 1889, still operate from Sommerville Road and have regularly advertised in the *Bishopston Parish Magazine*.

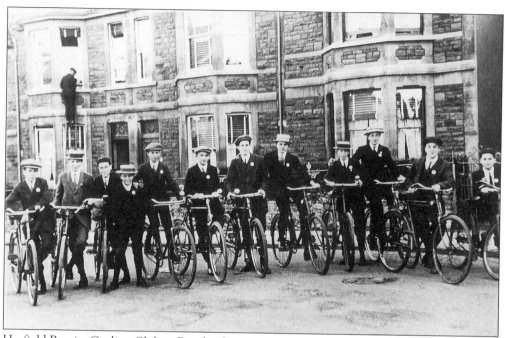

Horfield Baptist Cycling Club in Brynland Avenue, *c.* 1926.

Advertisement for S.W. Redwood & Son, *c.* 1912.

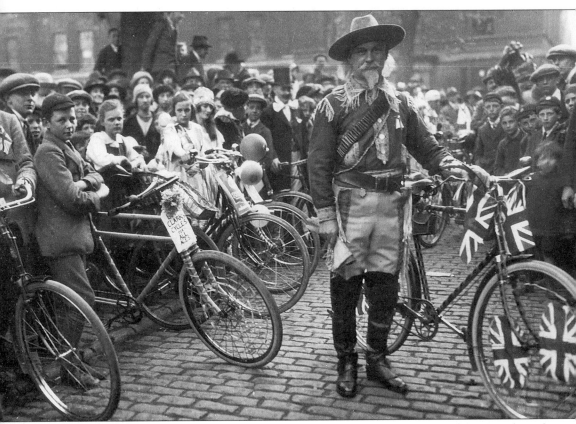

Arthur John Butt, of 21 Monmouth Road (1871–1930), dressed as Buffalo Bill for an early cycle promotion, c. 1910. He won cycle races in his early years, and was later well known in the Bristol area as a cycle-race referee. He ran a cycle shop near Bristol University, with his two sons Harold and Joe.

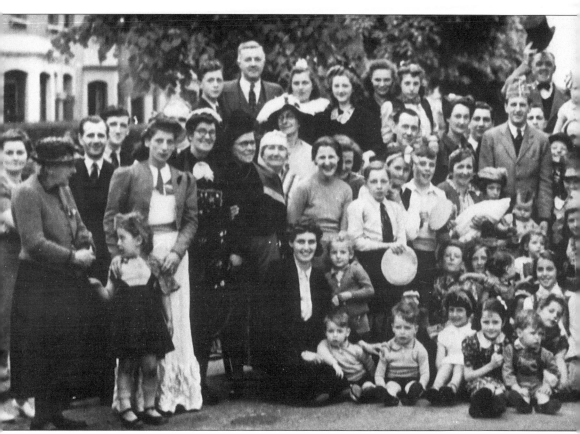

Egerton Road VE Day party, 9 May 1945. Rev Denis ('Spider') Hall is in the 'fancy' hat top right centre of picture; he later became Assistant Bishop on the Niger in West Africa.

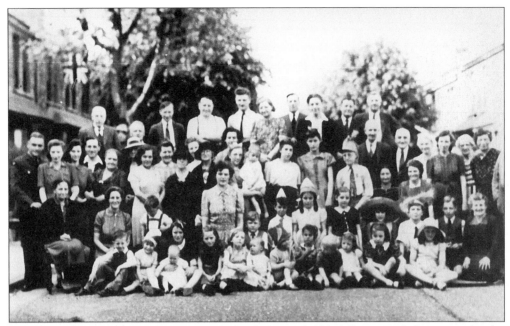

Monk Road victory street party, 1945. Paul Dirac (1902–84), one of the most famous twentieth-century physicists, was born in this road in 1902. He won the Nobel Prize in 1933 for his work on quantum mechanics.

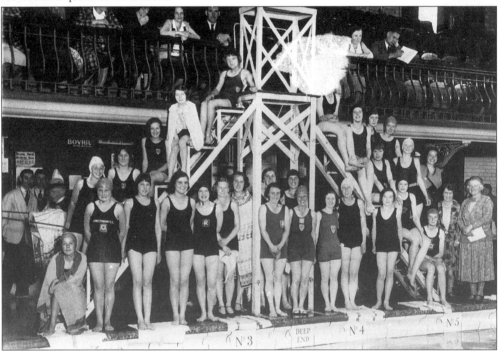

Bristol Ladies Swimming Club at Bristol North Baths, c. 1932. The baths were built in 1914 and were used by the War Ministry in the First World War to fabricate aircraft wings. From 1922 to 1936 a Mr Bruce Atkinson leased the baths, boarding them over, and operating the building as a cinema.

Bishop Road School, *c.* 1930. This school was opened on 6 January 1896 with three departments – infants, girls and boys, and was built at a cost of £8,815. Miss Edith Kellaway was head of the infants' school, which initially had 232 five- to eight-year-olds. The head of the girls' school was Miss Sarah Morgan with 184 eight- to fifteen-year-old girls, and Alfred Edgar was head of the boys' school with 186 eight- to thirteen-year-olds. It is interesting to note that in 1897 more staff were recruited so that class sizes could be *reduced* to between forty and fifty children!

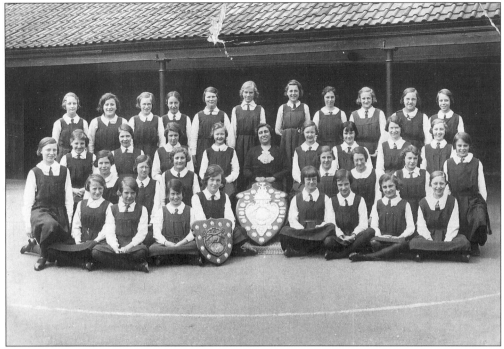

Bishop Road Girls' School choir with Miss Franklin, 1934–35 winners of the Bristol and Co-operative Eisteddfod shields. Bishop Road School was founded in 1896 in order to cope with the large numbers of children who were growing up in the area as a result of the housing developments of the 1880s and 1890s in Bishopston and Horfield.

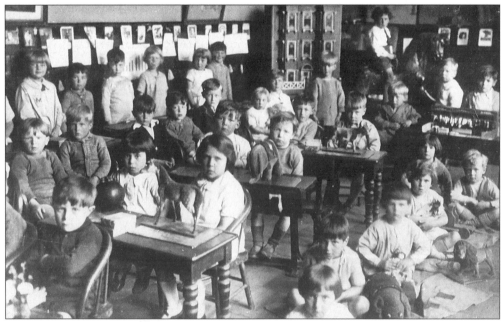

Miss Knott's class at Bishop Road Infants' School, c. 1929. Former pupils will remember the rocking horse pictured in the background.

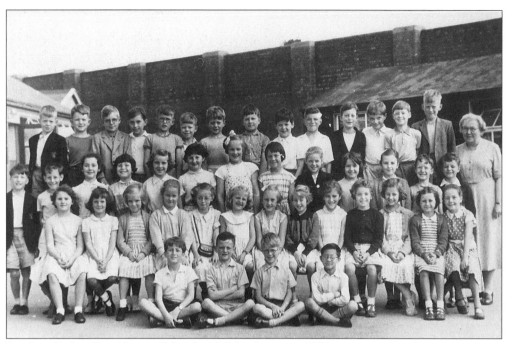

Pupils at Bishop Road Junior School with Miss Lewis, *c.* 1958.

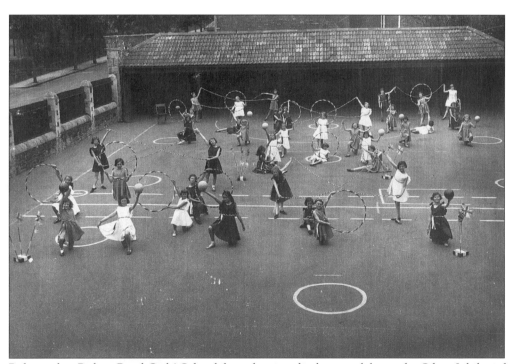

Rehearsal at Bishop Road Girls' School for a dancing display to celebrate the Silver Jubilee of King George V and Queen Mary in 1935.

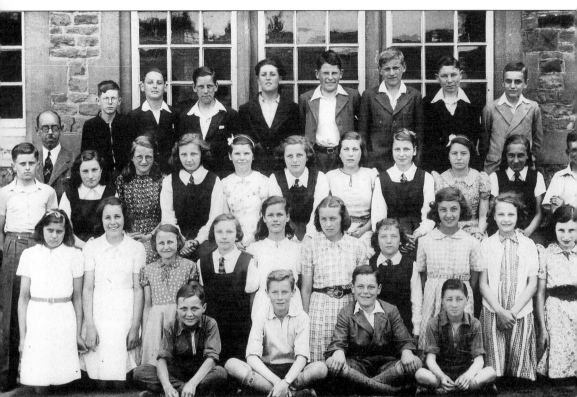

Form 3 (Mr Penberthy's class) at Bishop Road Senior Mixed School, July 1940. From left to right, back row: Peter Osborne, Laurence Britton, Cecil Tanner, Peter Kimberley, Donald Griffiths, Stanley Morse, Robert Holbrook, Peter Smith; third row: Mr Penberthy (teacher), Donald Price, Constance Vowles, Sheila Vincent, Enid Rogers, Gladys Sheppard, Marion Francombe, Barbara Barrett, Elizabeth Bailey, Brenda Tucker, Pat Lipley, Dennis May; second row: June Elkerton, Monevah Weeks, Veronica Gregory, Margaret Jones, Beryl Day, Joan Tyack, Colleen Harris, June Gould, Muriel Rogers, Betty McDonall; front row: Brian Gunn, Gordon Effer, Patrick Loney, Trevor Mugglestone.

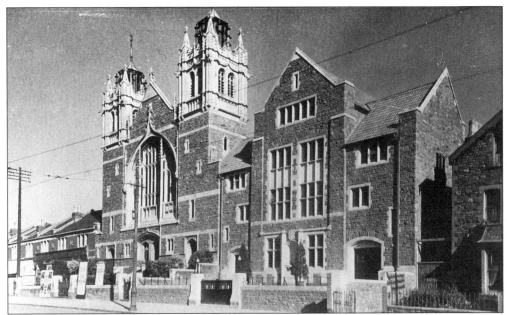

Horfield Baptist Church, Gloucester Road, Bishopston, *c.* 1930. The church was founded by 26 members of Broadmead Baptist Church who left to hold meetings at 10 Rowlay Road, now Thornleigh Road (*see page* 86). They moved to a mission hall in Gloucester Road (*see page* 87). In 1892, a new chapel (now the church hall) was built in Brynland Avenue. Building commenced in January 1900 on the present twin-tower chapel on Gloucester Road. The foundation stone was laid by Herbert Ashman, the first Lord Mayor of Bristol.

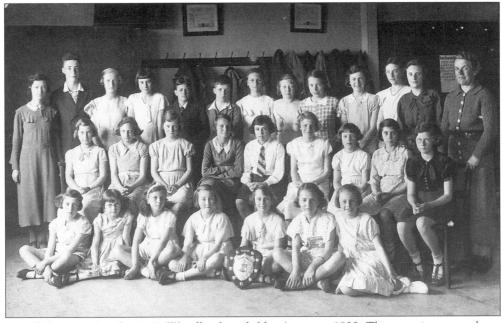

Bristol Co-operative Society's Woodlanders children's group, 1933. They met in rooms above the shop premises and their teacher was Mrs Chillcott, top right of the picture.

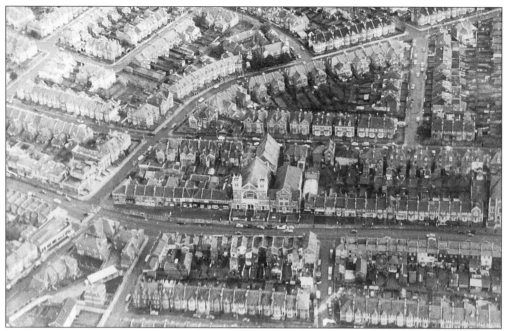

Aerial view of Gloucester Road, *c.* 1935. Horfield Baptist Chapel is in the centre of picture; Longmead Avenue runs from bottom left, crosses Gloucester Road and becomes Nevil Road which runs to top right; Horfield Prison lies between Longmead Avenue and Cambridge Road, bottom left.

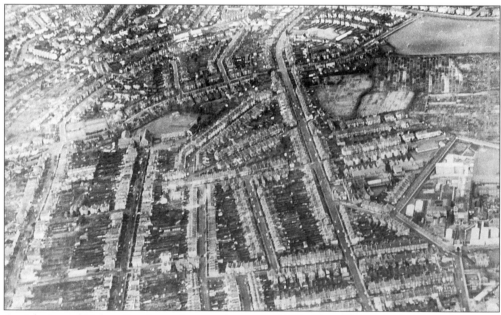

Aerial view of Bishop Road running up picture, *c.* 1935. Kings Drive crosses near the top of picture and joins Kellaway Avenue by Cotham School playing fields; Bishop Road joins Kellaway Avenue where Coldharbour Road commences; Bishop Road Schools are slightly to the right of centre where Cambridge Road joins Bishop Road; Horfield Prison occupies the area to the right of Cambridge Road.

The Church of St Bonaventure, *c.* 1955. The foundation stone of the new church was laid and blessed by Bishop Brownlow in July 1900, and the church was opened on 14 March 1901. Work on the interior continued for several years and in 1903 the high altar was embellished and new communion rails installed. Following the Second Vatican Council (1962–65), some changes to Catholic worship were made and a new altar was installed in 1974. Mass is now celebrated in English with the priest facing the congregation.

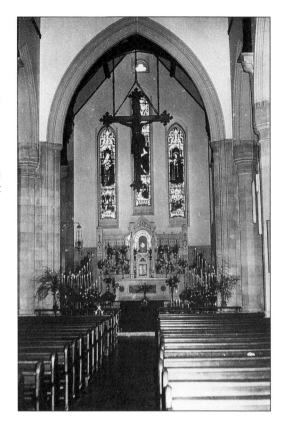

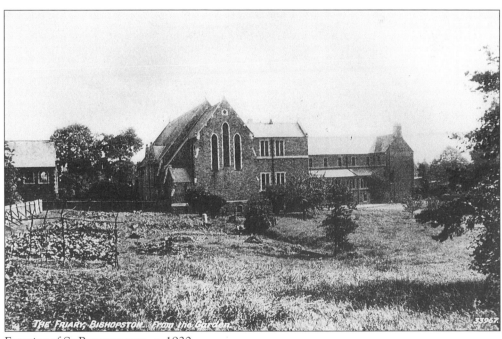

Exterior of St Bonaventure, *c.* 1920.

Skittling at the St Bonaventure summer fête, *c.* 1947. In the picture are Margaret Smith, Teresa Rigg, Sheila Pullin and Joan Toff.

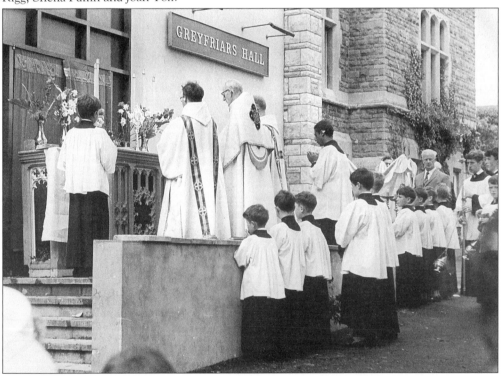

The opening of the new parish centre, Greyfriars Hall, in 1963. This has become the focal point of the social life in the parish and the venue for meetings, dances, socials, drama and other celebrations, and the home of the Greyfriars Club, with facilities for skittles and snooker, and a base for the Greyfriars Athletic football team.

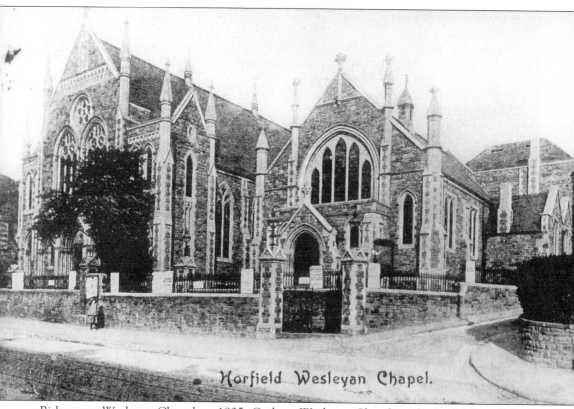

Horfield Wesleyan Chapel.

Bishopston Wesleyan Chapel, *c. 1935*. Cotham Wesleyan Church authorised Albert Pole to purchase the site occupied by a house called Cheltenham Villa for £600. The first church was opened in 1893, and was formed by members from the King Street circuit in the City Centre with Rev George Fletcher. The first minister was Rev James Redfearn, and there were 49 members. The original church was used for a schoolroom as well. No 245 Gloucester Road was purchased in 1926, and the church was extended. The premises are now occupied by the Kelvin Players.

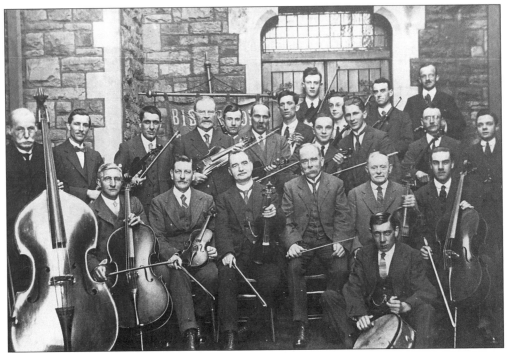

Bishopston Methodist Church orchestra, *c.* 1910.

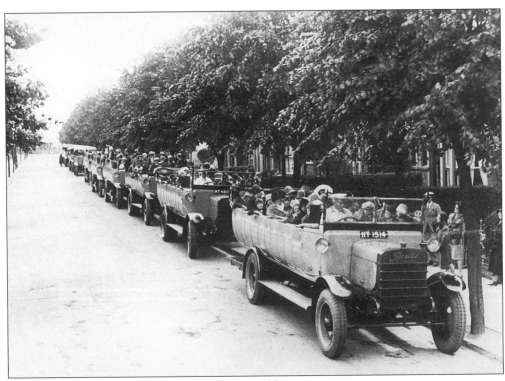

Line-up of charabancs in Brynland Avenue, *c.* 1905.

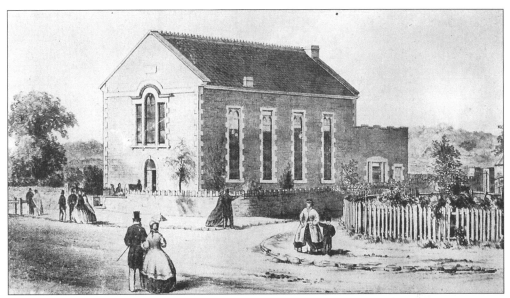

Berkeley Road Methodist Church in 1865. The church was closed in 1959, and the congregation joined the Bishopston Wesleyan Chapel on the corner of Gloucester Road and Wesley Road. The spire has been removed and the premises are now a tyre centre.

Pupils of dancing teacher Miss Sheila Love, 1945. Local girls Jeanne Wright, Audrey Billet, Pat Harwood, and Elizabeth Stewart are dressed as 'country folk' for a novelty dance. Miss Sheila Love taught ballet, tap, modern and national dancing in her studio at the bottom of Sommerville Road.

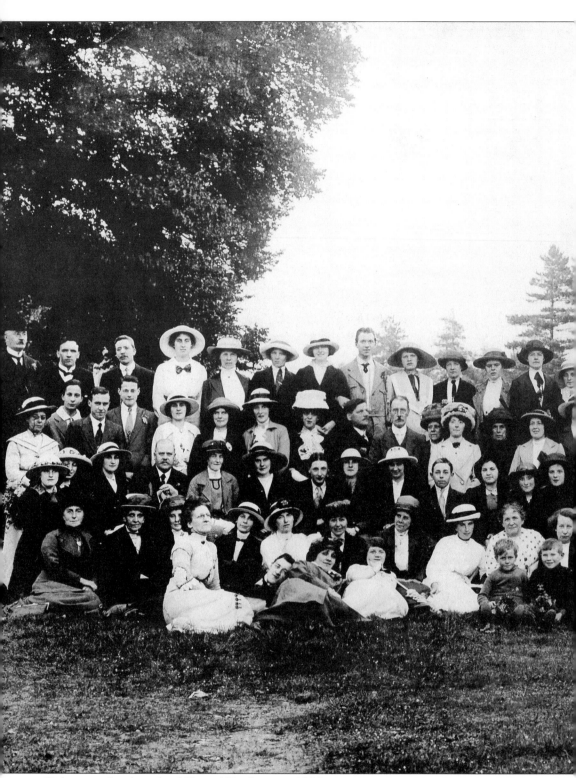

Bishopston Sunday school 'Penny' Fund picnic, 1914.

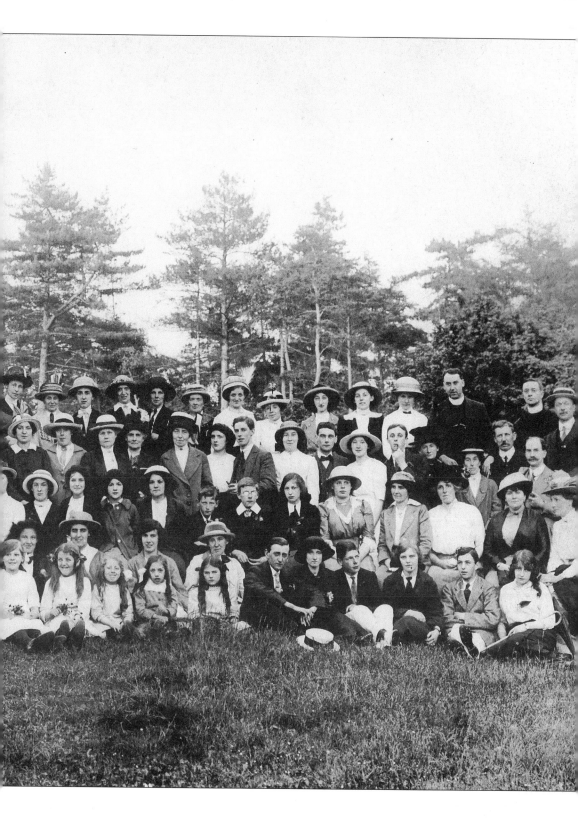

The Church of the Good Shepherd, Bishop Road, was dedicated on 31 December 1927 as a daughter church of St Michael and All Angels. It was built at a cost of £1,494 12s 8*d* to last for five years but stood for 31 years. This picture was taken *c.* 1931.

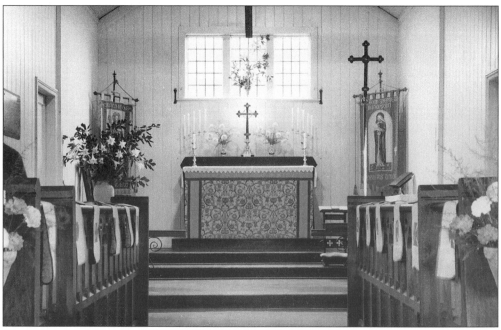

Sanctuary of the Church of the Good Shepherd, 1957.

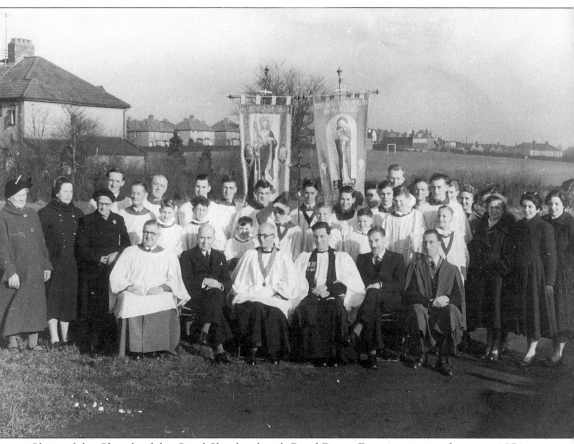

Choir of the Church of the Good Shepherd with Revd Denys Evans, priest-in-charge, *c.* 1951. This was before the completion of Kings Drive; Cotham School playing fields, bounded by Kings Drive and Kellaway Avenue, are in the background.

Bishop Road Boys' School production of Balfe's *Bohemian Girl*, *c*. 1936.

A Bishop Road School outing at Ashley Hill station, *c*. 1936.

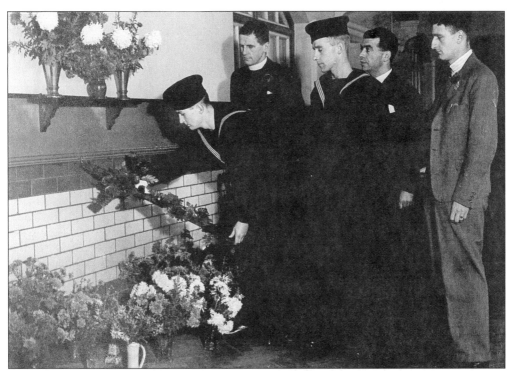

Revd D. Hall and Mr F. Philpott, headmaster of Bishop Road School, at a wreath-laying ceremony, *c*. 1942.

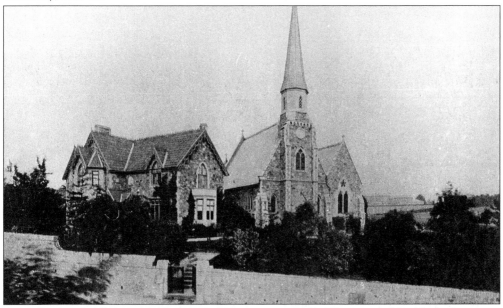

St Michael and All Angels' Church and Vicarage, *c*. 1880. The original building, consisting only of the nave, tower, and spire, was started in 1858 and was constructed at his own expense by Revd Henry Richards, rector of Horfield, as a memorial to members of his family. The church was consecrated on 28 February 1862 and in July of that year the new parish of Bishopston was created from parts of the parishes of Horfield and Stapleton.

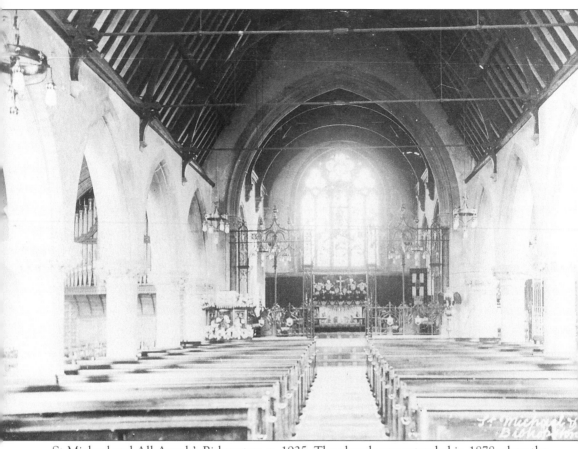

St Michael and All Angels', Bishopston, *c.* 1925. The church was extended in 1878 when the south transept, porch, and chancel were added. At this time the lady chapel, into which the Richards memorial windows were moved, was also built. The lectern was given by members of the congregation to celebrate the Golden Jubilee of Queen Victoria in 1887. The church was deemed unsafe in 1991 and the congregation moved to the Gospel Hall, near the corner of Egerton Road and Gloucester Road. Demolition work was due to start late 1997 and the site will probably be developed for residential homes for elderly people living in the area.

Girls' Friendly Society at Bishopston Parish Hall, *c*. 1929. This was run by Miss Winifred Jellis from 1927 to 1939. A later leader was Miss Elsie Weekes.

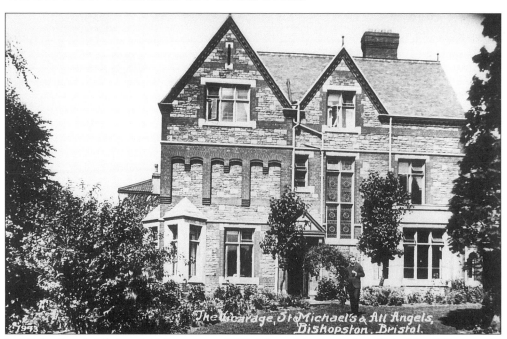

St Michael and All Angels' Vicarage, *c*. 1895. The original was demolished in 1891 to make way for a church extension and a new vicarage was built. The building pictured is now a private house.

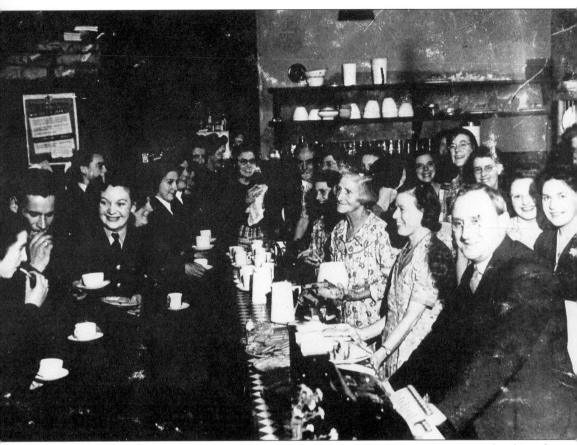

Forces canteen, Bishopston Parish Church Hall, Pigsty Hill, 1942. Mrs Down, wife of Revd R.H. Down, is on the till.

An envelope advertising Edward J. Brinsdon, Sons & Co. Ltd, wagon-wheel makers and importers of American wheels, *c.* 1904.

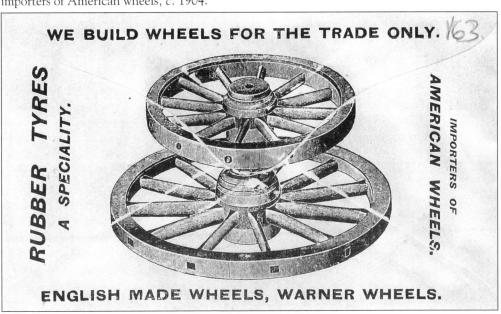

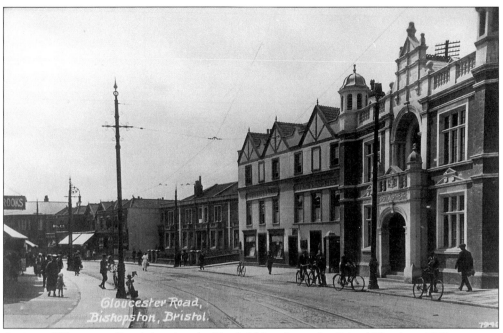

A view of Gloucester Road showing the Horfield Inn (now the Bristol Flyer), *c.* 1942.

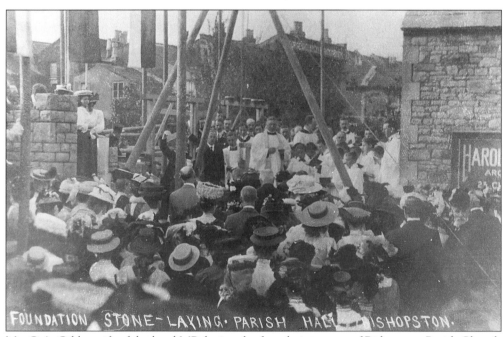

Mrs G.A. Gibbs, wife of the local MP, laying the foundation stone of Bishopston Parish Church Hall on Pigsty Hill, 11 September 1907.

Two

Horfield

The name Horfield is derived from the old English 'horu' indicating 'a muddy stretch of open land'. There is an alternative theory which is that 'Hore' or 'Hori' was a chief killed in a fight between the Saxons and the Romano-British and who was then buried in a local tumulus. The actual spelling of Horfield has gone through several changes. In Domesday Book it was spelt 'Horfelle'; when given by Robert Fitzharding to Bristol Abbey it was 'Horsfield'; and by the reign of Edward I it had become 'Harfelle'.

Originally, Horfield was a small village bounded by a large forest (Horwood) which tended to restrict communication with other areas. It was said that travellers were afraid to cross Horfield by night, and preferred to go in parties. The village, which was based around the church and the Common, gave its name to a large parish bordered by Westbury on Trym, Stapleton and St Paul's out-parish.

The Common has from earliest times been divided into north and south sections, and there were twenty-four 'rights of Common' between 14 May and 13 February. Commoners were permitted to let their rights, and they could appoint a hayward whose duty it was to warn off trespassers. By 1900, houses were being built round the Common, and the construction of these revealed evidence of early settlers – in 1896, for example, workmen laying gas pipes had come across human bones. In the 1920s, when Frederick C. Jones wrote about Horfield in the Evening Times and Echo, there still existed a tumulus and earthworks near the Rectory. It had been examined in 1880 and was found to contain bones, metal, and remains of Roman mortar. This tumulus is recorded on Seyer's map of 1813, not far from the present traffic lights. This map and other information about Horfield was published in Horfield Miscellanea (1900) by Rev Fanshawe Bingham, rector of Horfield (1878–1899).

There is an abundance of water all round the Common which was, of course, of great importance to early settlers; there was a mineral-water well near Mrs Rosling's farmhouse. Quab Farm stood south-east of Horfield Castle together

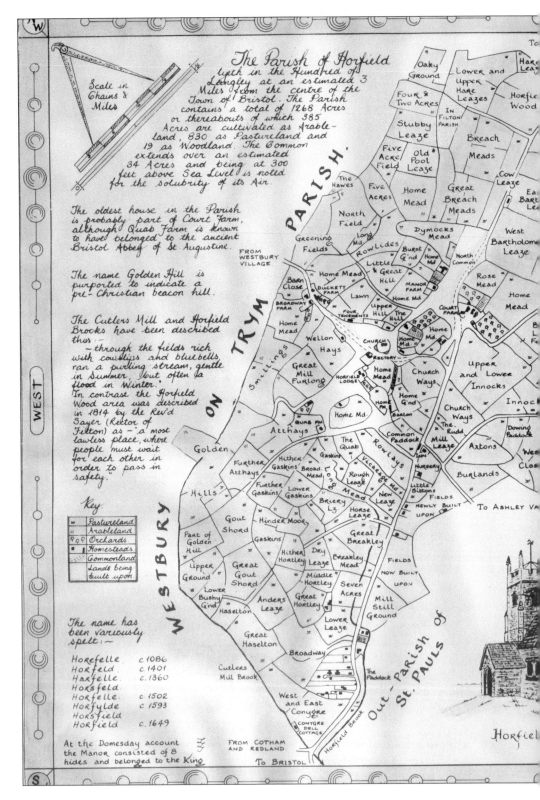

The Parish of Horfield lyeth in the Hundred of Longley at an estimated 3 Miles from the centre of the Town of Bristol. The Parish contains a total of 1268 Acres or thereabouts of which 385 Acres are cultivated as Arable-land, 830 as Pastureland and 19 as Woodland. The Common extends over an estimated 34 Acres and being at 300 feet above Sea Level is noted for the solubrity of its Air.

The oldest house in the Parish is probably part of Court Farm, although Quab Farm is known to have belonged to the ancient Bristol Abbey of St Augustine.

The name Golden Hill is purported to indicate a pre-Christian beacon hill.

The Cutlers Mill and Horfield Brooks have been described thus :—
"— through the fields rich with cowslips and bluebells, ran a purling stream, gentle in Summer but often a flood in Winter."
In contrast the Horfield Wood area was described in 1814 by the Rev'd Sayer (Rector of Filton) as — 'a most lawless place, where people must wait for each other in order to pass in safety."

Scale in Chains & Miles

Key:
Pastureland
Arableland
Orchards
Homesteads
Commonland
Lands being built upon

The name has been variously spelt :—

Horefelle.	c 1086
Horfeld.	c 1401
Harfelle.	c 1360
Horsfeld	
Horfelle.	c 1502
Horfylde	c 1593
Horsfield	
Horfield	c 1649

At the Domesday account the Manor consisted of 8 hides and belonged to the King

W

WEST

S

PARISH ON TRYM

WESTBURY

Out - Parish of St Pauls

FROM WESTBURY VILLAGE

FROM COTHAM AND REDLAND

TO BRISTOL

To ASHLEY VA

Horfiel

Oaky Ground
Lower and Upper Hare Leazes
Hare Lea
Horfie Wood
Four & Two Acres
IN FILTON PARISH
Stubby Leaze
Breach Meads
Five Acre Field
Old Pool Leaze
Cow Leaze
The Hawes
Five Acres
Home Mead
Great Breach Meads
Ea Bart
West Bartholome Leaze
North Field
Dymocks Mead
Greening Fields
Long Md
Rowlides
Burnt G'nd
Home Md
North Common
Rose Mead
Home Mead
Barn Close
Home Mead
DUCKETT FARM
Little & Great Hill
MANOR FARM
Home Md
BROADWAY FARM
FOUR TENEMENTS
Lawn
Upper Hill
The Hill
COURT FARM
Home Mead
Wellon Hays
Home Md
Home Md
B L
Smillings
Great Mill Furlong
HORFIELD LODGE
CHURCH
RECTORY
Home Mead
Church Ways
Upper and Lower Innocks
Home G'nd
Home Mead
Home G'nd
Banton
Church Ways
Innoc
QUAB FM
Home Md
The Rudd
Dowing Paddock
Atthays
Home Md
Common Paddock
Mill Leaze
Axtons
Golden
The Quab
Gaskins
Rowlays
Vicarage Md
Nursery
Burlands
We Clo
Further Atthays
Hither Gaskins
Broad
Rough Leaze
Little Buttons
FIELDS
Hills
Further Gaskins
Lower Gaskins
Briery Lz.
Horse Leaze
New Leaze
NEWLY BUILT UPON
Gout Shord
Hinder Moor
Great Breakley
Part of Golden Hill
Gaskins
Hither Hortley
Dry Leaze
Breakley Mead
FIELDS NOW BUILT UPON
Upper Ground
Great Gout Shord
Middle Hortley
Seven Acres
Mill Still Ground
Lower Bushy G'nd
Anders Leaze
Great Hortley
Haselton
Lower Leaze
Great Haselton
Broadway
Cutlers Mill Brook
The Paddock
Horfield Brook
West and East Conygre
CONYGRE DELL COTTAGE

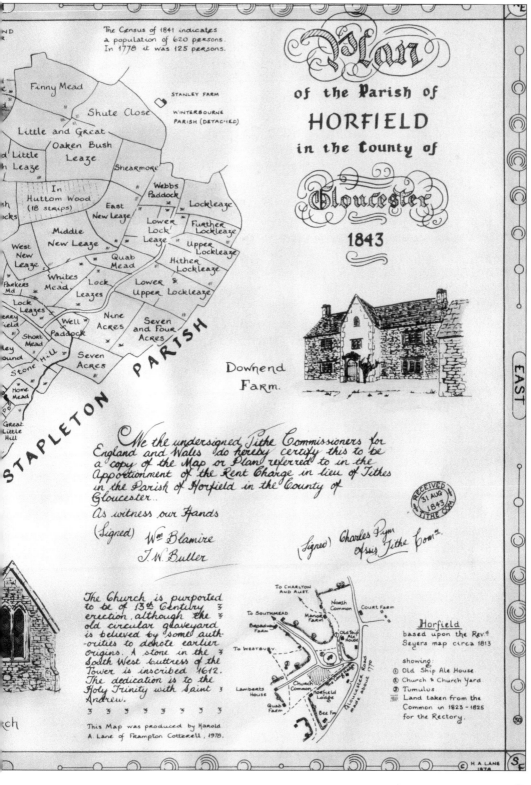

The Census of 1841 indicates a population of 620 persons. In 1778 it was 125 persons.

Plan

of the Parish of

HORFIELD

in the County of

Gloucester

1843

STANLEY FARM

WINTERBOURNE PARISH (DETACHED)

Finny Mead

Shute Close

Little and Great Oaken Bush Leaze

Little Leaze

Shearmore

In Huttom Wood (18 strips)

Webbs Paddock

East New Leaze

Lockleaze

Middle New Leaze

Lower Lock Leaze

Further Lockleaze

West New Leaze

Quab Mead

Upper Lockleaze

Hither Lockleaze

Whites Mead

Lock Leazes

Lower & Upper Lockleaze

Parkers Md

Lock Leazes

Nine Acres

Seven and Four Acres

Well Paddock

Short Mead

Stone Hill

Seven Acres

Home Mead

Great Little Hill

STAPLETON PARISH

Downend Farm.

We the undersigned Tithe Commissioners for England and Wales do hereby certify this to be a copy of the Map or Plan referred to in the Apportionment of the Rent Charge in lieu of Tithes in the Parish of Horfield in the County of Gloucester.

As witness our Hands

(Signed) Wm Blamire

J.W. Buller

(Signed) Charles Pym Assis Tithe Comr.

RECEIVED 31 AUG 1843 TITHE COM.

The Church is purported to be of 13th Century erection, although the old circular graveyard is believed by some authorities to denote earlier origins. A stone in the South West buttress of the Tower is inscribed 1612. The dedication is to the Holy Trinity with Saint Andrew.

This Map was produced by Harold A. Lane of Frampton Cotterell, 1978.

To CHARLTON AND AUST.

North Common

Court Farm

To SOUTHMEAD

Manor Farm

Broadmead Farm

Old Ship Ale House

To WESTBURY

Church Common

Lamberts House

Horfield Lodge

Gloucester Road made about 1770

Quab Farm

Bee Fm

Horfield

based upon the Revd Seyers map circa 1813

showing:

1 Old Ship Ale House
2 Church & Church Yard
3 Tumulus
Land taken from the Common in 1823 - 1825 for the Rectory.

© H A LANE 1978

NE · EAST · SE · 50

59

with several 'quabs' or fishponds. (Highfield Grove was originally called Quab Road.) These fishponds belonged to St Augustine's Abbey and were used by the priests of Horfield Church; the area near the garages still becomes very wet in times of heavy rain. Golden Hill Farm was demolished in 1932 and its land was developed as Birchall Road and Malmesbury Close. The lower end of Radnor Road was developed early in the twentieth century, while Bristol Rugby Football Club had their pitch higher up the road on land which was developed when the club moved to Filton Avenue in 1921.

Horfield Church was originally dedicated to St Andrew, and had a circular graveyard. Apart from the tower, the church, rededicated to the Holy Trinity, was rebuilt in 1847 having already been extensively altered from 1831 onwards; further improvements took place in 1893. After the Second World War, Bristol City Council developed what was known as the Manor Farm estate, and some of the roads bear names of people connected with the church. In the churchyard is the grave of John Frost, Mayor of Newport, who was transported to Van Diemen's Land for his involvement in the Chartist movement of the late 1830s and 1840s. His gravestone was renovated some years ago and was visited by Neil Kinnock, then leader of the Labour Party. Also at St Andrew's is a commemorative tablet in memory of Archie Walters who, with his younger friend, wandered into the area in the winter of 1874 while playing truant from school. The children became lost and Archie gave his companion his coat in order to keep him warm – the younger child survived, but Archie did not.

An article published in the Bristol Evening Post in 1935 describes a walk that could be taken in the 1870s from Bishopston, via Horfield, to Westbury. It describes going through a gate at the top of Berkeley Road and walking on through open farmland to Dugar's Wood then famed for its wildlife. To the left were fields of cowslips running down to a few houses in Zetland Road. The transformation of this rural area into a Bristol suburb began with the development of Bishopston. By 1880, a steam-tram had reached Horfield, and in April 1883 Horfield Prison was opened on a site originally put aside as a pleasure garden.

In 1885 an extension of the City's boundaries was proposed, and Horfield was included in this scheme. As more and more of the area became developed with housing, it was realised that Gloucester Road was the only through-route providing access. As a consequence, Kellaway Avenue was opened in 1921 connecting Coldharbour Road with the Common. (Rt Hon F.G. Kellaway MP, who was born in the locality, was postmaster-general at the time.) Muller Road was built in 1928 to connect with Eastville and led to more house-building.

Previous page: Map of the parish of Horfield, produced by Harold Lane of Frampton Cottrell in 1978.

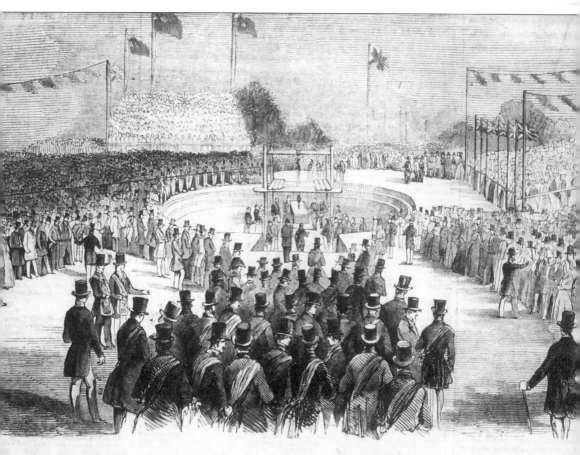

LAYING THE FOUNDATION-STONE OF THE BARRACKS AT HORFIELD, NEAR BRISTOL.

A contemporary engraving showing the laying of the foundation stone of Horfield Barracks on 3 June 1845 by R.W. Bro. Frederick Charles Husenbeth, Deputy Provincial Grand Master of the Province of Bristol Freemasons. The barracks were built in 1847 for £57,000, as the home of the Rifle Brigade. The Duke of Wellington visited the barracks on more than one occasion and Wellington Hill and the Wellington Hotel were named after him. The buildings were demolished in 1966 to make way for GPO offices. After the Second World War, housing was erected on land acquired from the War Department and roads were named after famous battles in which the 'Glorious Glosters' had taken part – two in particular are Inkerman and Dorian (should be Doiran).

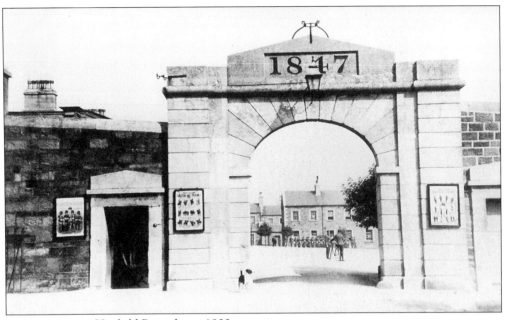

Entrance gate to Horfield Barracks, *c.* 1900.

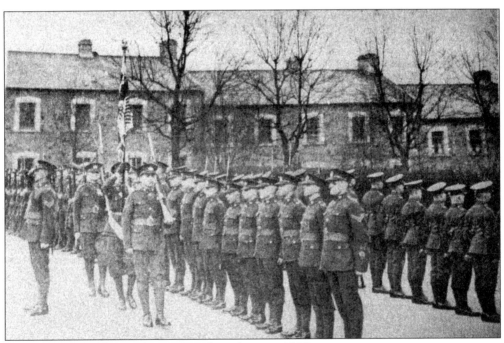

Soldiers at Horfield Barracks parading the colours, *c.* 1930.

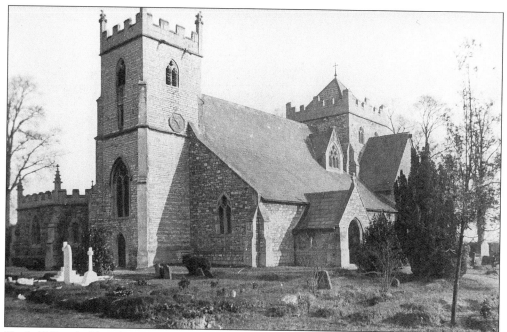

Horfield Parish Church, *c.* 1950. There is mention of a chapel at Horfield in 1219 and records of a church of St Andrew at Horfield in 1502. The present church was rebuilt in 1847 (*see page 80*).

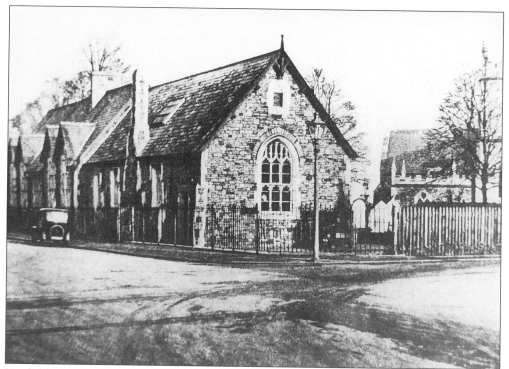

Horfield Church School, *c.* 1929.

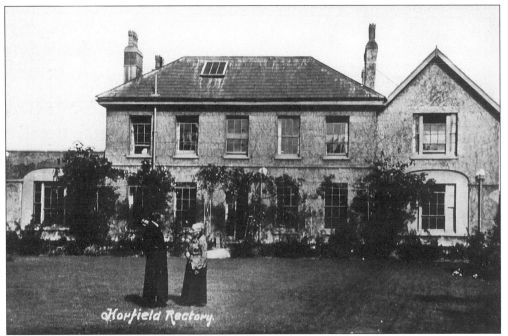

Horfield Rectory, *c.* 1925, showing Canon Clark with his mother. The Rectory was built through the efforts of Revd S. Seyer when he came to Horfield in 1813 as curate incumbent. One acre of land was set aside from the Common for the purpose and vested in the perpetual curacy of Horfield. The Rectory was built in 1822.

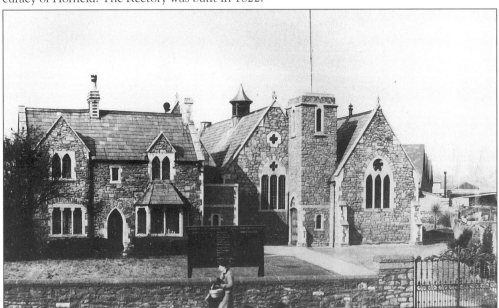

St Edmund's Church, Gloucester Road, *c.* 1950. This was built in 1860 as St Edmund's Trust School, originally for both boys and girls, but after 1880 for boys only. It remained a school until 1905 when it became the Church of St Edmund, King and Martyr. This was closed in 1978 and the buildings were sold to a firm of silk-screen printers. The schoolmaster's house on the left of the picture was demolished prior to the building of the Trustee Savings Bank (TSB).

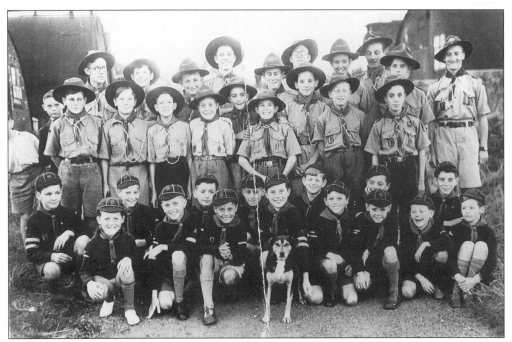

141st Scout Troop, which was attached to Horfield Parish Church, 1949. The troop merged with Horfield Methodist Scouts in the mid-1960s to become the 62nd Troop.

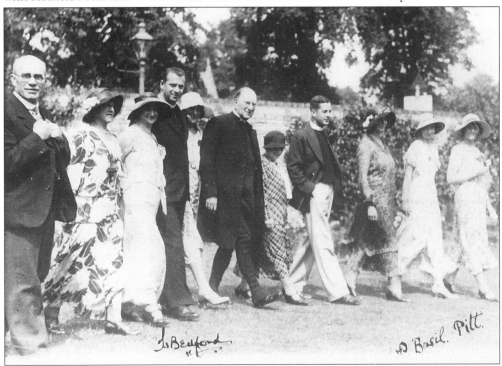

Rev H. Bedford (priest-in-charge at St Edmund's) and Revd Basil Pitt (curate at Horfield) enjoying a pleasant afternoon at a garden party in the Rectory *c.* 1937, possibly with members of the Mothers Union.

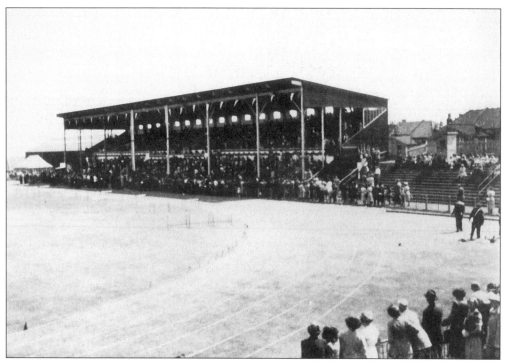

Opening of the Memorial Ground (Bristol RFC's playing fields) by the Lord Mayor G.B. Brittan on 24 September 1921. It was so-named to honour those who had died in the First World War.

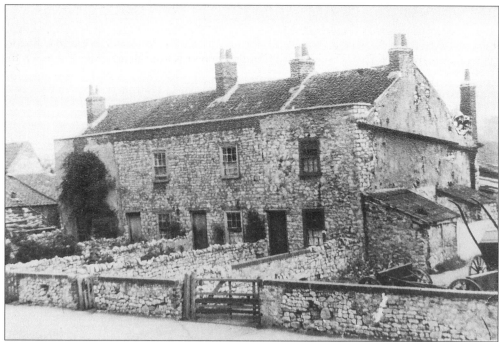

Wade's cottages on Gloucester Road, below the junction with Dongola Avenue; part of Wade's yard can be seen on the right. These cottages and others down to Nevil Road were demolished to make way for purpose-built shops (*see page 11*).

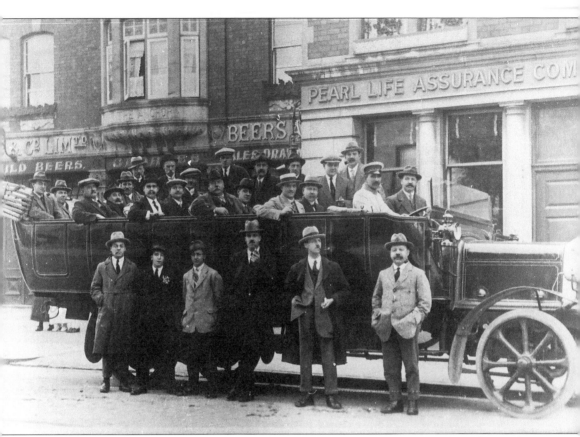

Licensed Victuallers Association charabanc outing, *c.* 1920, about to set off from the Anchor public house (now Bar Oz). The landlord Charlie Philpott is front right. The premises on the right are now Lloyds Bank.

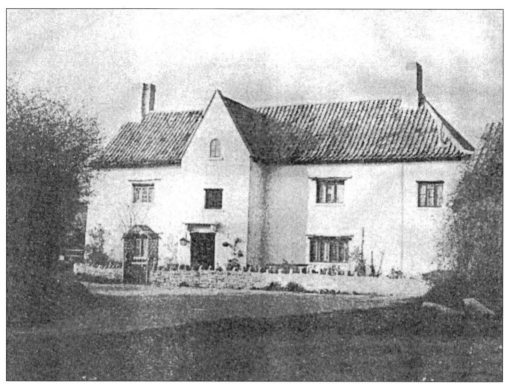

Downend Park Farm was probably built in the first half of the seventeenth century and the central gable and stone mullioned windows are indications of its Tudor origin. The farm was for many years occupied by the Sherrell family and, in 1948, Margaret Sherrell led a strong local campaign to save the farmhouse from demolition. An agreement was reached that Bristol Corporation would leave the building untouched as long as Miss Sherrell was alive. In 1982 the City Council discovered that Miss Sherrell had died two years previously, but after a further protest movement the farm was again saved and purchased by the Harris family. The present occupier is Helen Woodward. This picture dates from *c.* 1948.

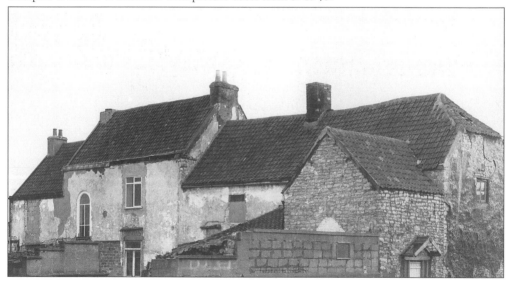

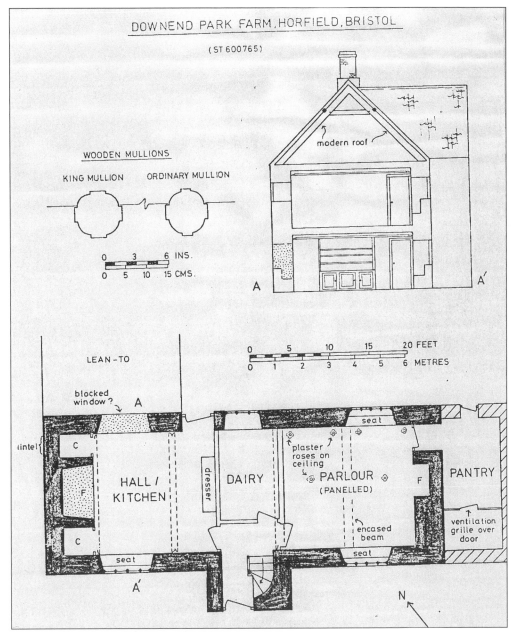

Plan of Downend Park Farm, *c.* 1982.

Opposite: Downend House Farm was separated from Downend Park Farm by an avenue of high elm trees. This is now the extension of Downend Road into Dovercourt Road, the trees being replaced by new housing. The farm was for many years occupied by the Dewfall family and many people may recall the small shop adjoining the farmhouse , which was run by Mrs Dewfall to sell milk and bread. After the Dewfalls left and the road was made, the farm was turned into a general shop run by the Chidgey family; this closed around 1982 when the owners died. Today, after demolition work in 1985, only a small portion of the original farmhouse remains as part of a residential property. This picture dates from 1985.

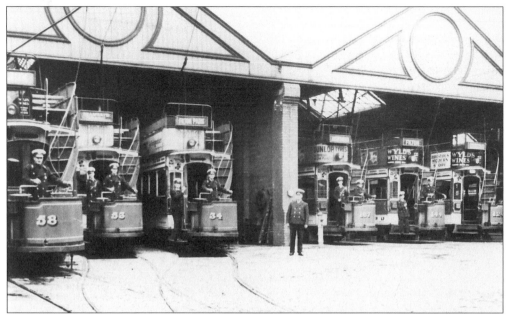

Ashley Down tram-terminus (also known as Horfield tram-depot), Gloucester Road, *c.* 1930. This was built in 1892 with stables for horses. On 22 December 1900 the tram-line was extended to Horfield Barracks and the depot was converted to accommodate 56 electric trams. On 21 March 1907 the line was further extended to Filton Church. The depot ceased to be used when the system closed down due to the bombing of the power station on 11 April 1941. It became a motor-car showroom and later became a covered market – the Victoria shopping centre. It was replaced by a petrol station and behind that a medical centre in 1993. The entrance to the latter is in Church Road, and some of the tram-lines can still be seen in the car park.

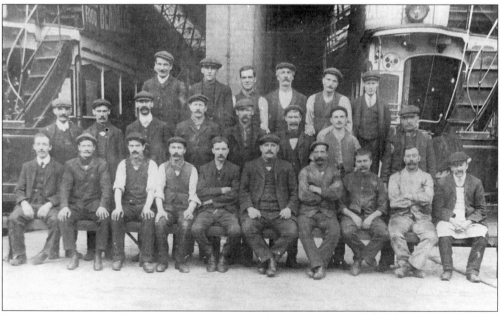

Maintenance crews at Horfield tram-depot, *c.* 1934.

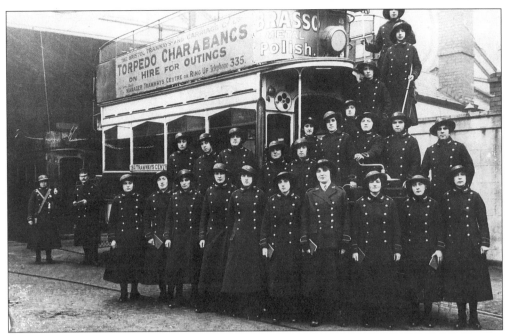

Tram-conductresses and inspector wearing wartime steel helmets, *c.* 1940.

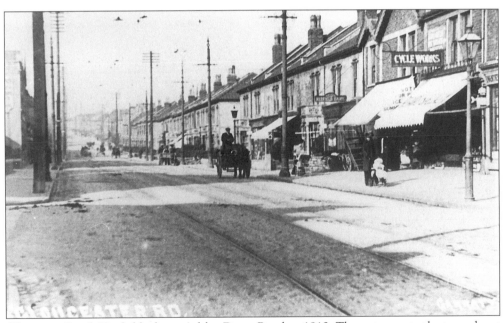

Gloucester Road, Horfield, above Ashley Down Road, *c.* 1912. The entrance to the tram-depot can just be seen on the left of the picture with the Victoria Inn just beyond it.

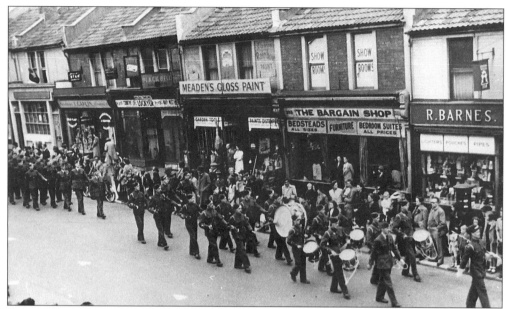

RAF parade in Gloucester Road, *c.* 1940.

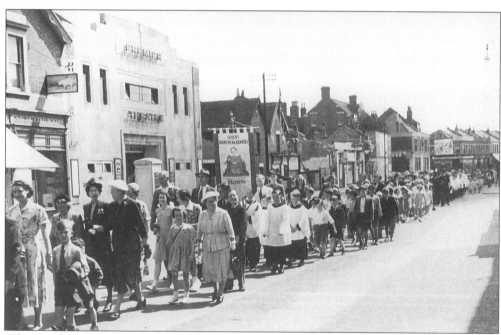

Whit Sunday procession passing the Premier Cinema, Gloucester Road on the way to Horfield Common. The cinema was built on the site of the former Horfield Baptist Mission Hall (*see page 87*). It was opened in the 1920s and closed in 1964, and has since been used as a builder's merchants and latterly as a KwikSave supermarket.

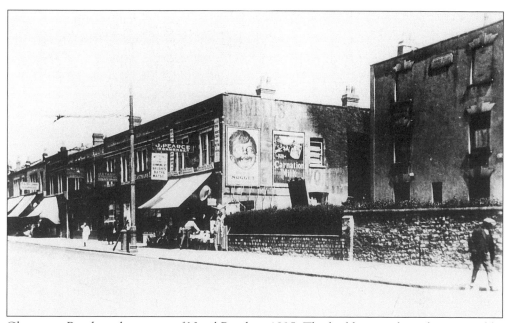

Gloucester Road, at the corner of Nevil Road, *c.* 1895. The building on the right was used by the Conservative Club and later replaced by more suitable premises. It is now known as the Horfield & Bishopston Unionist Club and celebrates its centenary in 1999.

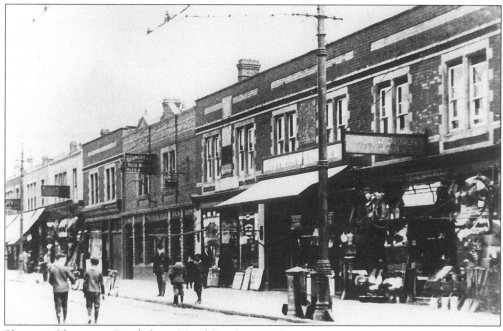

Shops in Gloucester Road above Nevil Road, *c.* 1915.

Kellaway Avenue was opened in 1921 by Postmaster-General F.G. Kellaway MP, who was born nearby. Kellaway Avenue connected Coldharbour Road, Golden Hill cottages and the Common. This view is towards Gloucester Road from near the church, *c*. 1925.

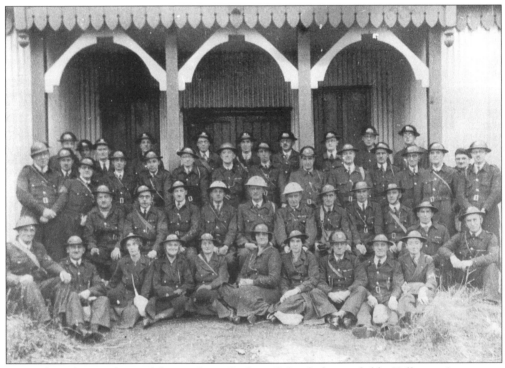

Air-raid wardens in front of the pavilion, Cotham School playing fields, Kellaway Avenue, *c*. 1941.

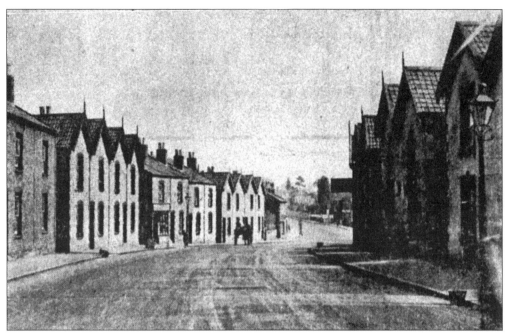

Kellaway Avenue at Golden Hill, looking towards Horfield Common with Longmead Avenue joining on the right and the Kellaway Arms public house right of centre, *c.* 1925.

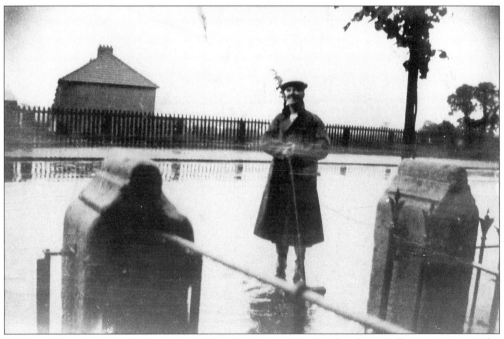

William Henry Lewis with broom *c.* 1930, clearing up after the floods in Kellaway Avenue. The picture was taken near the top of Longmead Avenue (left) before the rank of shops in Kellaway Avenue were built.

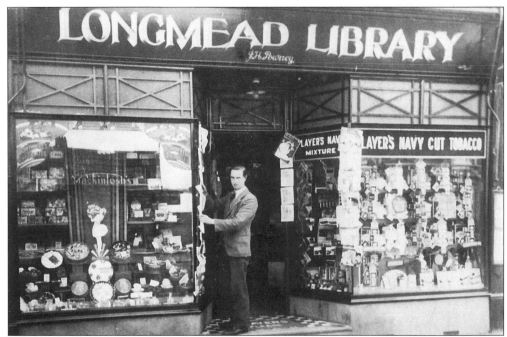

Longmead Library, Kellaway Avenue, *c.* 1931. The name refers to nearby Longmead Avenue and was something of a 'red herring'. It needed some detective work to discover that the address was in fact No 188 Kellaway Avenue. You can just see the proprietor's name J.H. Powney. The shop has since been modernised and is now Kellaway News under the ownership of Mr and Mrs Dean.

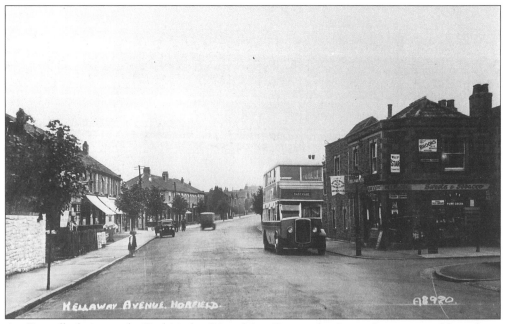

An Eastville bus outside 'Rich's' the 'Noted Ice Cream shop', on the corner of Lansdown Terrace and Kellaway Avenue in the early 1930s. Longmead Library is the first shop visible on the left above the fence.

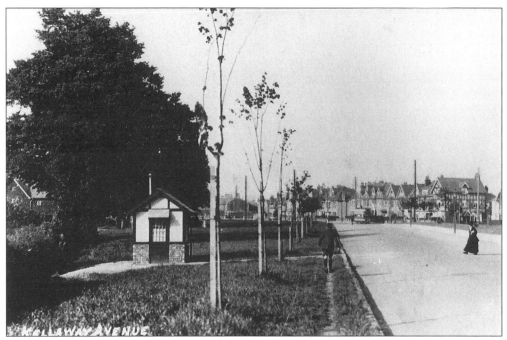

Kellaway Avenue looking towards Gloucester Road, c. 1925.

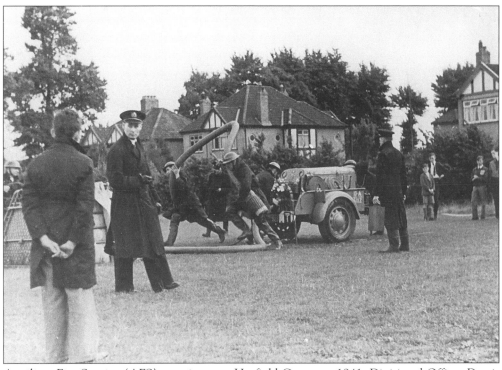

Auxiliary Fire Service (AFS) practice near Horfield Common 1941. Divisional Officer Day is in the foreground facing the camera.

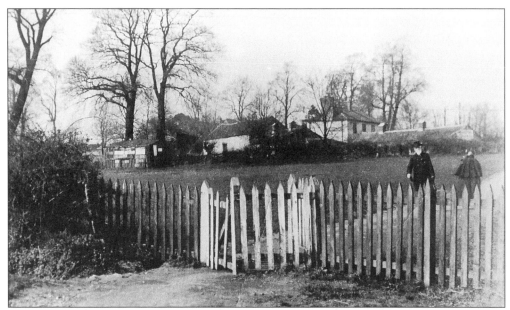

Quab Farm. 'Quab' has Latin origins and means a kind of fish (gudgeon) or a fish-pond. Highfield Grove nearby was originally named Quab Road but the residents objected and the name was changed. This picture shows the view from the back of 12 Highfield Grove.

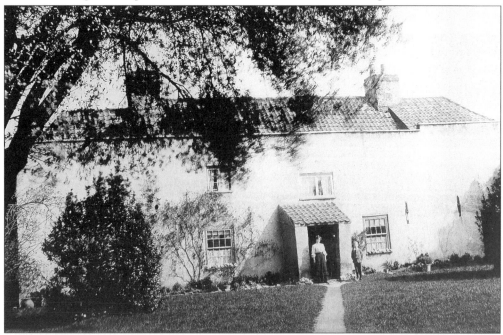

Rosling Cottage, previously the Ship Ale House (built in 1770). Kate Cordwell, seen with her son Eric, was one of ten children of William Rosling (b 1833 d 1890) and Emma (*née* Barlow, b 1839 d 1913) of Berry Lane Farm, Horfield. The cottage was demolished to make way for Weston Crescent, and a modern detached house bears the name Rosling Cottage. The Wellington public house at the junction of Wellington Crescent and Gloucester Road took the Ship Ale House's licence.

Manor Farm, Horfield Common, *c.* 1950.

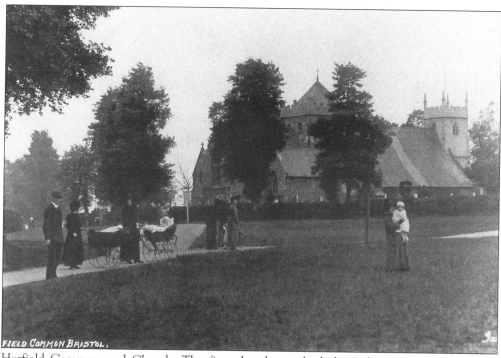

Horfield Common and Church. The first church was built by Robert Fitzharding, lord of Berkeley in the reign of Henry I, and dedicated to St Andrew. The circular churchyard may indicate that early Christians built on an existing pagan religious site.

According to Rev Fanshawe Bingham, it seems certain that a Saxon church was here; the base of the font, with its scalloped ornamentation, is of that period. A tower was added in 1612 to the church built by Robert Fitzharding, and further enlargement came in 1831 with the addition of a gallery. In January 1847, the church was rebuilt with the exception of the tower and rededicated as the Church of the Holy Trinity on 22 December 1847 by Rev James Henry Monk, Bishop of Gloucester.

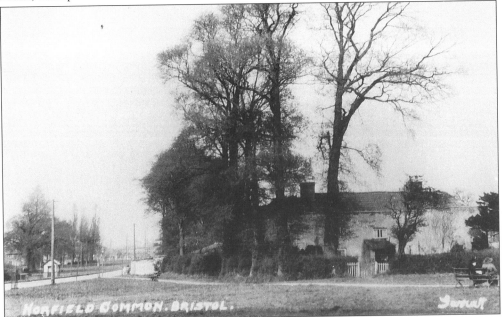

Horfield Common adjacent to the church. Two modern houses – Shaldon House and Rosling Cottage – now occupy the site of the houses in this picture. The 'hut' (nobody can shed any light on its purpose) has since been demolished (*see page 77*).

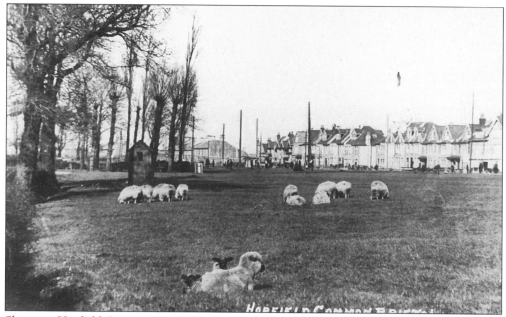

Sheep on Horfield Common, *c.* 1905, prior to the building of Kellaway Avenue.

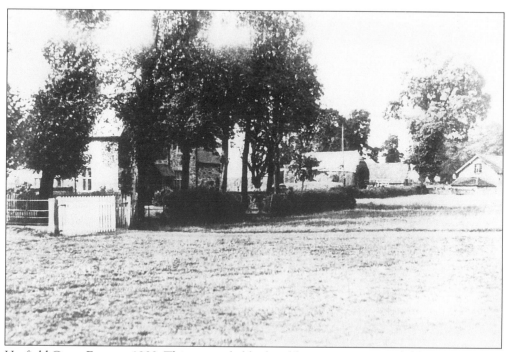

Horfield Court Farm, *c.* 1900. This was probably the oldest property in Horfield and once stood near the junction of Muller Road and Gloucester Road. Court Road perpetuates the name. Part of the farm went to form the Barracks.

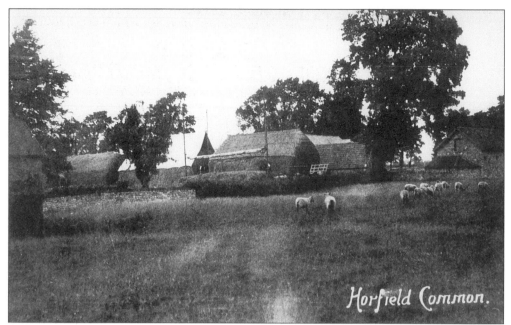

Horfield Common and Horfield Court Farm in the early 1900s.

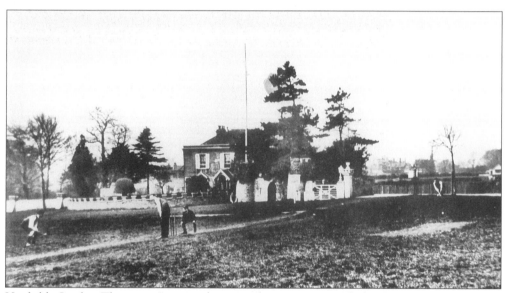

Horfield Castle. This wasn't a castle as such – more 'mock battlements' which were incorporated into a private property owned by a Mr Lambert and known until 1851 as 'Lambert's House'. The house is now demolished but No 218 Kellaway Avenue still has a small portion of the 'castle' forming part of its garden wall.

Estate of CHARLES HENRY TUCKER, deceased.

Highly-important Auction of RESIDENCES, FLATS, DWELLING HOUSES, and SHOPS
AT

HORFIELD,
CLIFTON, REDLAND, MONTPELIER,
LAWRENCE HILL, STAPLETON ROAD, and CITY,
BRISTOL.

MR. A. VICTOR OSMOND

has been favoured with instructions to SELL by AUCTION, at the GRAND HOTEL,
BRISTOL, on

WEDNESDAY, MAY 15 1935, at Three o'clock :

The Undermentioned

RESIDENCES, FLATS, DWELLING-HOUSES, and SHOPS

Producing a Total Income of over

per £3,000 Annum.

Lot 1.—The Singularly-Attractive DETACHED RESIDENCE AND GROUNDS, known as

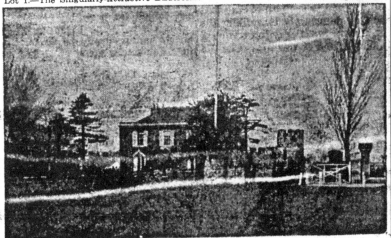

Lot 1.—

HORFIELD CASTLE
KELLAWAY AVENUE,

HORFIELD COMMON,
BRISTOL,

for many years in the occupation of the deceased.

THE RESIDENCE contains:—On the Ground Floor: Glazed Porch, Tiled Hall, Drawing Room (with French Windows), Dining Room (with fine Mahogany Mantel and Surround), Library or Morning Room, Butler's Pantry (with Dressers and Sink), Larder, Kitchen (with Eagle Combination Grate), Scullery, Wine Store, Outside w.c., and Two Coalhouses. On the First Floor (approached by Main and Secondary Staircases): Five Bedrooms, Bathroom (with Bath h. and c., and Washbasin), w.c. On the Second Floor: Bedroom and Two Attic Bedrooms.

THE OUTBUILDINGS include:—GARAGE, 3-Stall Stable and Harness Room (with Loft over), Boiler House (with Loft over), Open Shed, Tool House, Coal House, etc. Two GREENHOUSES (10ft. x 18ft. and 6ft. x 18ft.), and Garden Light (6ft. x 18ft.).

THE GROUNDS, which are attractively laid out and well kept, include: LAWNS (with Pavilion or Summer House) Flower Beds and Borders, and KITCHEN GARDEN stocked with Choice Fruit Trees.

Electric Light and Power. Telephone. Gas. Company's Water. Public Sewer.

THE ENTIRE PROPERTY is enclosed by a substantial Stone Wall, and contains by estimation

1a. 0r. 14p.

FREEHOLD, subject to a Rent Charge of £5 7s. 0d.

THIS RESIDENCE AND GROUNDS is situated in a UNIQUE POSITION adjoining HORFIELD COMMON and overlooks the BRISTOL GRAMMAR SCHOOL RECREATION GROUND.

TO BUILDERS, ESTATE DEVELOPERS, AND OTHERS,

Special attention is directed to this Property, which has a very valuable frontage to KELLAWAY AVENUE of about 450 feet, and the Southern portion of the Grounds affords room for the erection of SIX or more good-class VILLAS, without in any way interfering with the residential amenities or exclusiveness of the Residence.

Advert for the sale of Horfield Castle.

83

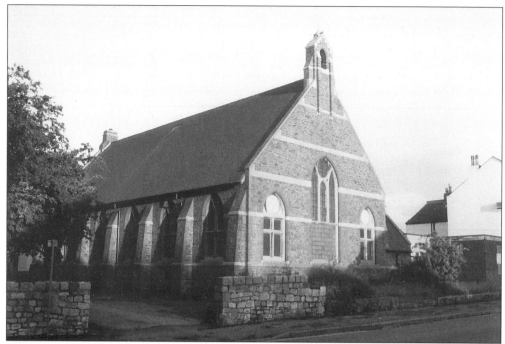

The original Mission Church of St Gregory, Filton Road, Horfield, *c.* 1920. This was built in 1911 and became the church hall in 1934.

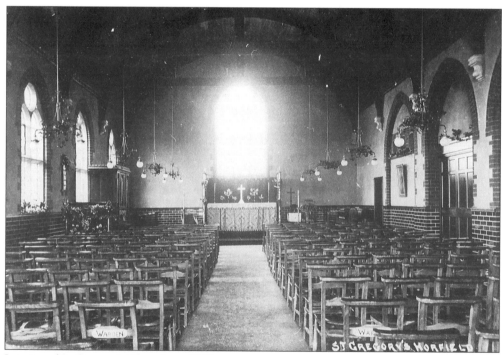

Interior of St Gregory's Church, *c.* 1935.

Garage premises of Jim White, motor engineer, Church Road, Horfield, on the corner of Maple Road. The photograph shows his five children: Vi, Stan, Gladys, Howard and Olive outside the garage. The business is now Stone's Garage.

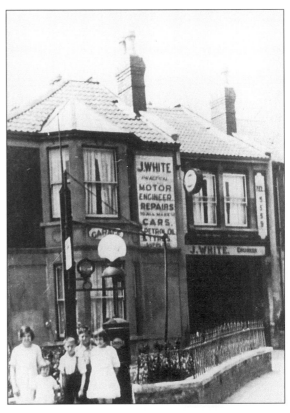

Street party in Thornleigh Road, 1945.

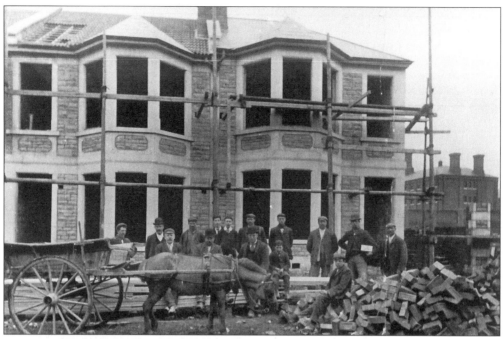

No 28 Radnor Road showing other houses being built, *c.* 1903. The builder, fifth from left wearing the bowler hat, was the grandfather of Ann Threader.

The first Mission Rooms (1882–89) of Horfield Baptist Church, 10 Rowlay Road (now Thornleigh Road). Founded by a small group from the Broadmead Baptist Chapel Men's Bible class, known as the Pilgrim Band, the Mission Rooms could accommodate up to eighty people.

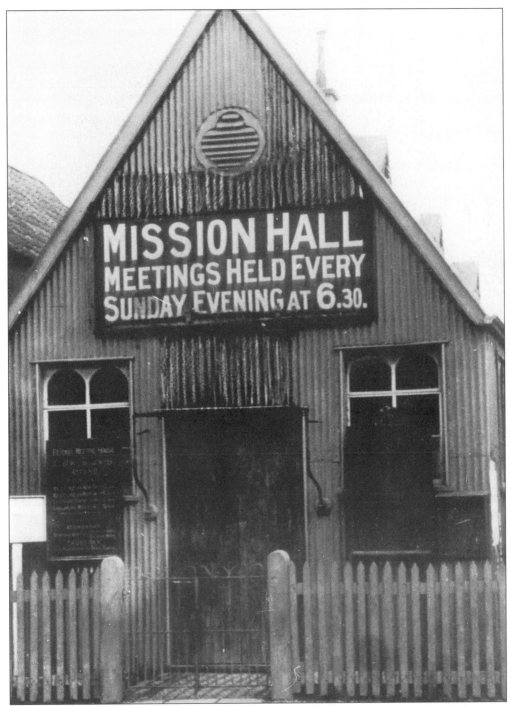

Horfield Baptist Mission Hall (the 'Iron Chapel'), 1890. Nicknamed 'the Tin Tabernacle', it was on the site (from 1889 to 1895) now occupied by KwikSave, and formerly by the Premier Cinema, A.E. Alders, and U.B.M. Builders' Merchants, respectively. The congregation moved from here to Brynland Avenue, and later to the present building on Gloucester Road (*see page 39*).

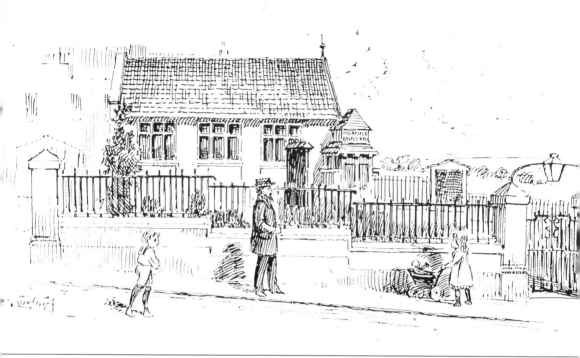

Horfield Gospel Hall, Ramsey Road. This was built in 1910 for the use of the Christian Brethren who had previously met in a private house. It was used by the Brethren until 1934 when their congregation outgrew the building and they moved to the Ebenezer Chapel in Filton Avenue. The hall was sold to the Gospel Standard Strict Baptists who used it until 1980 when the last member of their congregation died. In the same year Rev K.A. Harris was invited to inaugurate a new church in the building which is now named Horfield Reformed Baptist Chapel. He remains the pastor there today.

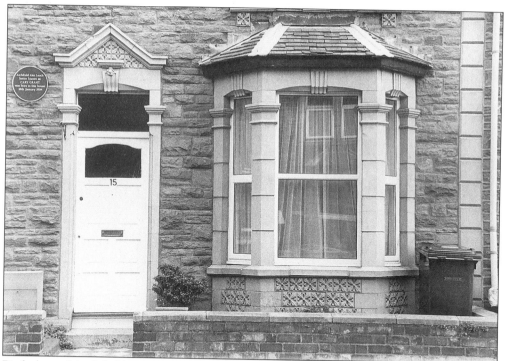

Birthplace of Archibald Leach, better known as the film actor Cary Grant. He was born in this house in Hughendon Road on 18 January 1904 and ran away from home to work in a circus. He later went to America where he made his career in films.

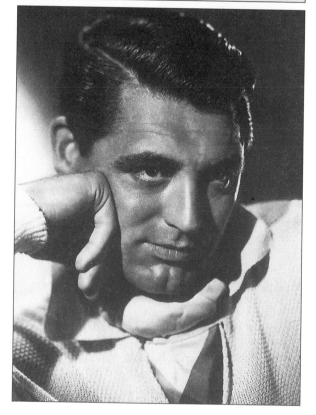

Cary Grant.

'Lil' (Lilian Tyte) pictured on her retirement after selling newspapers for 57 years, over fifty of which were spent on the corner of Ashley Down Road and Gloucester Road, outside the Royal Oak (now the John Cabot Inn).

Three
Ashley Down

Although changed in recent years by the removal of several fine large houses and the destruction of trees, this area retains a character of its own due to the allotments and the excellent views across Bristol. Furthermore, it is not hemmed in by housing development. The railway and Muller Road form a natural boundary on one side, and the area merges with Horfield and Bishopston on the other.

There is evidence of Roman or Romano-British settlement in the area, with a villa standing on Ashley Hill and a Roman road passing through the valley. In 1170, William, Earl of Gloucester gave the land of Ashley in perpetual alms to the monks of St James' Priory, for the honour of his family. There is no definite proof that the Benedictine monks had a house on Ashley Down, but as the prior who was subject to the Abbey of Tewkesbury was an important landowner, and would have needed a property from which to look after his lands, it is reasonable to assume that they did. All this of course, changed with the dissolution of the monasteries in the reign of Henry VIII.

It was from Ashley Down that Bristol's citizens obtained some of their water supply. Water was carried from near the Muller Orphanage to Ashley Hill, Baptist Mills, Newfoundland Street, The Horsefair and the Quay pipe in the City Centre. In the sixteenth century records show that 5/6 was once spent removing dead cats from the pipe!

As the centuries passed, Ashley Down became the home of Bristol merchants and the well-to-do. An example of this is Ashley Court, built or acquired by Sir Humphrey Hooke, who also had homes at Corn Street and Kings Weston. In the late seventeenth century the estate of Ashley covered a large area, and took in 'Hooke's Mill' nearby, this then being a grist mill. Ashley Court was demolished in 1876, and this site and adjoining land was turned into building plots, at a time when Bishopston and Horfield were starting to be built on. The first houses on Ashley Down were on Osborne Avenue and eight properties on the main Ashley Down Road, now near one of the entrances to Sefton Park

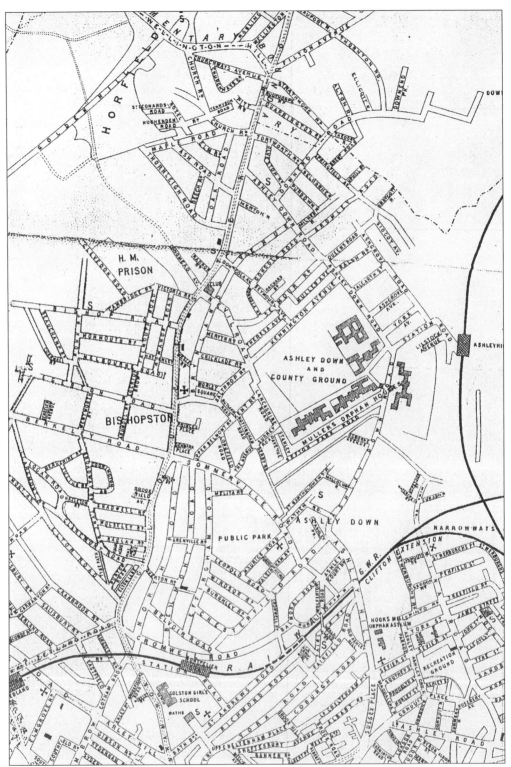

Street map showing Ashley Down, *c.* 1910.

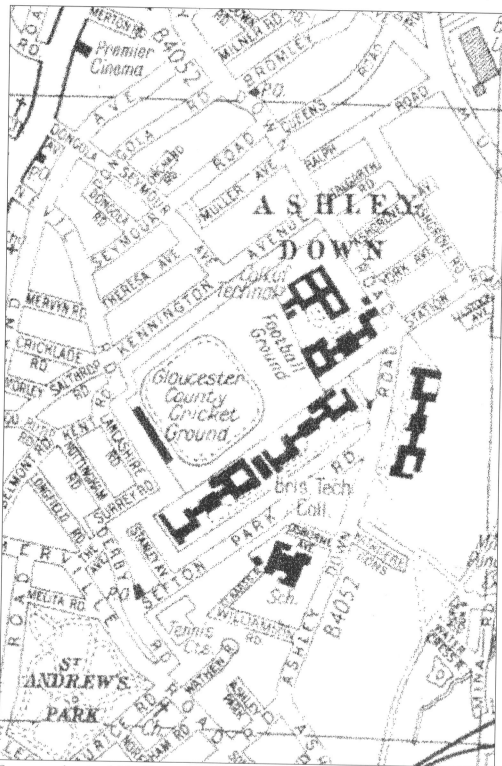

Street map showing Ashley Down, *c.* 1950.

School.

Ashley Manor House, at the foot of Ashley Hill, was part of St James' Priory until 1626. In 1733 this Tudor property was bought by Andrew Hooke, and became known as Hooke's Mills. The Blue Maids orphanage occupied the house from 1795 to 1829 and Henry Jones, the inventor of self-raising flour, was resident in 1864. Subsequently, however, the house's beautiful interior was allowed to fall into ruins and the building was demolished in 1911. In 1829 a new building for the orphans had been opened and in 1833 it had sixty girls. The orphanage closed in 1930 and the Salvation Army acquired the building; the property was demolished in 1972 and warehouses were later constructed on the site.

Ashley Down had several lovely mansions, the majority now sacrificed for modern housing:

Ashley Grange was a large Victorian house, on the corner of Ashley Down Road and Chesterfield Road and towards the end of its life it was used as a nursing home. Demolition came in 1936, several houses now occupying its site.

Tudor Lodge was a two-hundred-year-old farmhouse, and was used to accommodate post-war refugees before being demolished in 1967; the site is now occupied by Nos 247–265 Ashley Down Road.

Down View flats presently occupy the site of Down View, another large Victorian house, almost opposite Tudor Lodge. (In the wall between the end of Sefton Park Road and the houses which replaced Tudor Lodge is an old milestone, its inscription now lost).

Ashley House, on the corner of Williamson Road, has survived, and is now used by a youth club and the Windsor playgroup. In the 1920s Walter Bryant, a former Lord Mayor of Bristol, resided here, while nearby another Lord Mayor, William Eyles, lived at Holdenhurst.

An example of a later housing development is Kathdene Gardens, built on the garden of Glenfrome House. This makes Ashley Down different in one respect from Horfield or Bishopston but in other ways it closely followed their pattern of housing development, especially at the Gloucester Road end of Ashley Down. The Gloucester Road serves as the main shopping area but small business centres grew up for the local people. In Ashley Down Road there are still many different trades but shops, for example at the bottom of Station Road, have now ceased to trade.

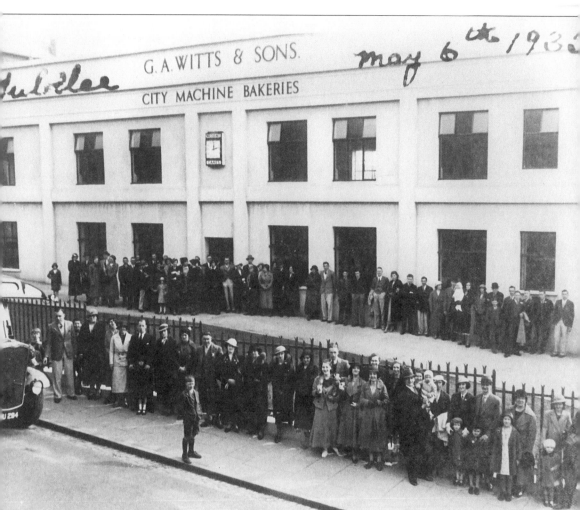

Witts Bakeries, Ashley Hill, pictured during the celebrations for the Silver Jubilee of King George V and Queen Mary, 6 May 1935. The bakery was near the site of Ashley Manor House.

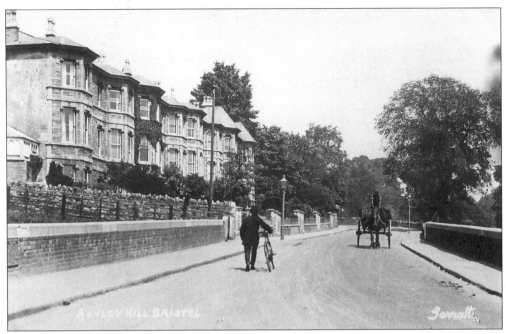

On the railway bridge near the top of Ashley Hill, c. 1910. The houses on the left have not been changed.

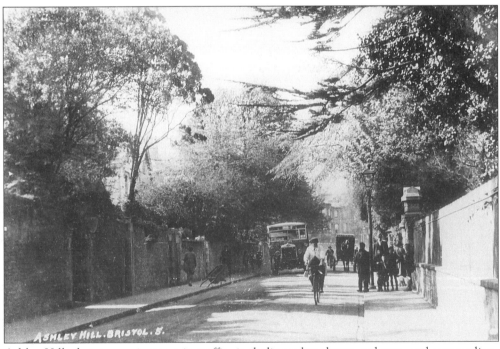

Ashley Hill, showing an increase in traffic, including a bus, horse and cart, and two cyclists, c. 1925.

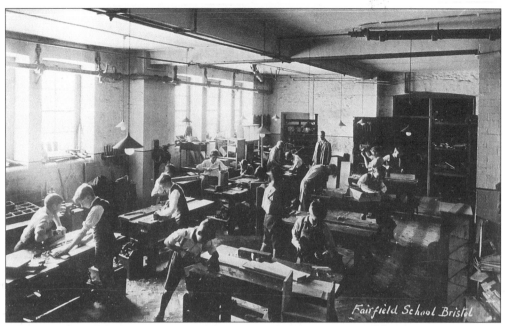

Woodworking class at Fairfield Grammar School, Ashley Down, *c*. 1920.

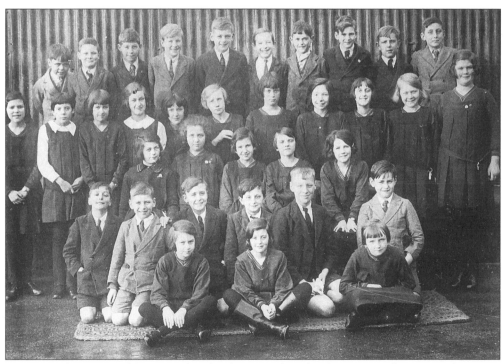

Class 1 Alpha at Fairfield Grammar School, 1931. The school was opened in September 1898. The architect was W.L. Bernard and the builder was J. Perkins.

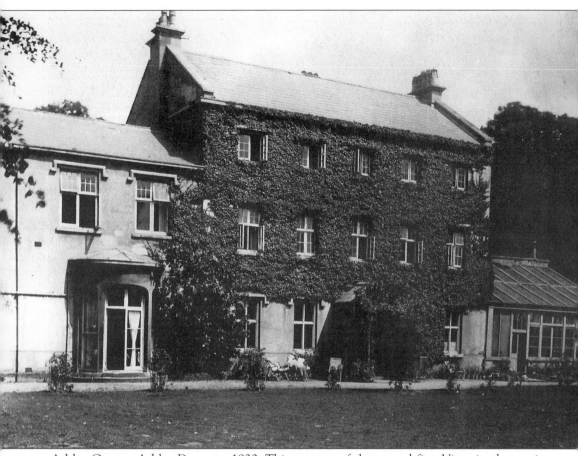

Ashley Grange, Ashley Down, *c.* 1920. This was one of the several fine Victorian houses in Ashley Down and had a croquet lawn and stables at the rear. Once the home of the famous cricketer, Dr W.G. Grace, it became a nursing and maternity home in 1919 and was demolished in 1936. St Andrew's Bowling Club, founded in 1924, was established in its grounds.

Ashley Down Road at the junction of Williamson Road, and the entrance to Ashley House, *c.* 1912.

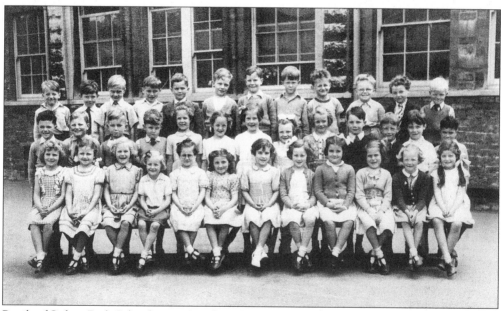

Pupils of Sefton Park School, *c.* 1958. The school was built on the paddock of Ashley House as a result of the decision to allow Fairfield School to deliver purely secondary education. The builder was George Humphreys of Eastville, and the school opened in 1910. The first headmaster was C.H. Cooper and he remained until 1927.

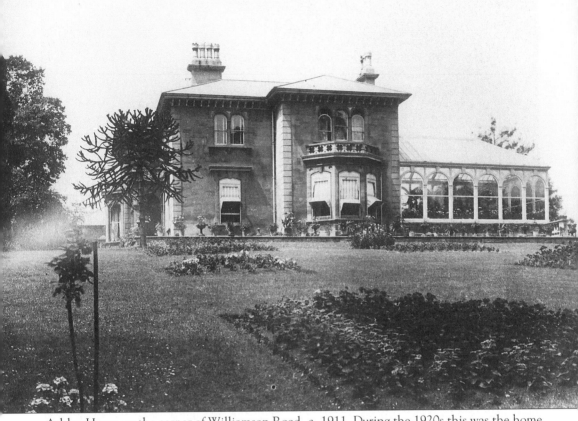

Ashley House on the corner of Williamson Road, *c.* 1911. During the 1920s this was the home of Walter Bryant a former Lord Mayor of Bristol. It has survived as a youth club and is also used by Windsor Playgroup displaced from David Thomas Memorial Church.

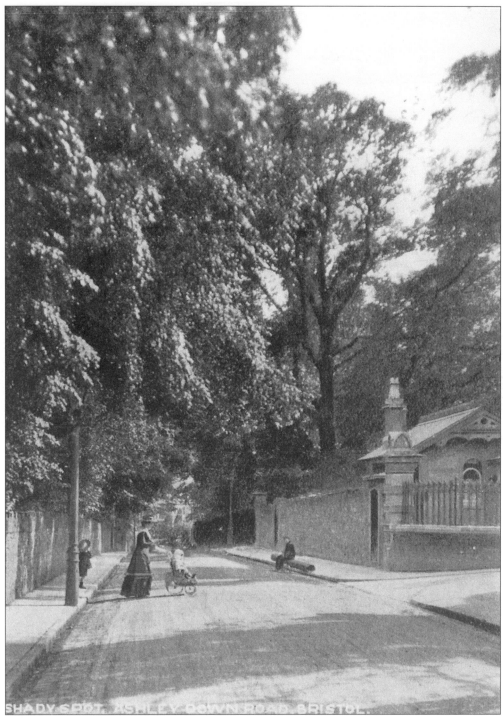

SHADY SPOT, ASHLEY DOWN ROAD, BRISTOL.

Ashley Down Road looking towards Chesterfield Road, *c.* 1905. The Lodge on the right belonging to Ashley House was demolished to make way for road-widening, the gateposts having been retained. The last tenant of The Lodge was Mrs Appleby. Note the large trees which were felled to make way for 1920s and 1930s housing.

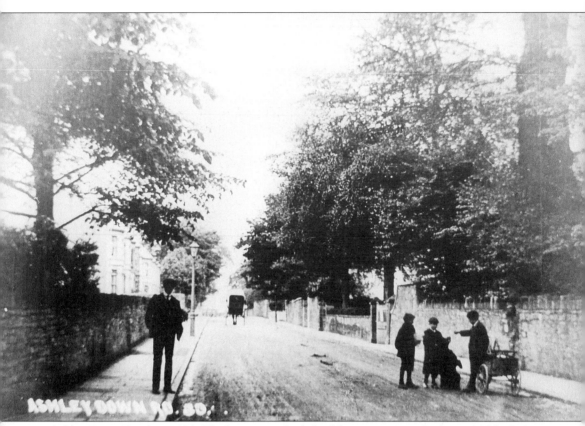

Ashley Down Road, *c.* 1920. The houses on the left of the picture were built in 1895 by Robert Osborne, whose name is remembered in the road between the two ranks of houses. They were originally called Osborne Terrace and were built in the orchards of Tudor Lodge (once situated where the 1960s houses now stand). Mr Garbutt lived at No 281 for over seventy years. On the other side of the road is Glenfrome House which was built in 1827. In 1852 Robert Charleton, a Quaker, moved in. He manufactured pins at Kingswood and was a benefactor of the Colston Hall. Note the dancing bear, an occasional feature of street entertainment in days gone by.

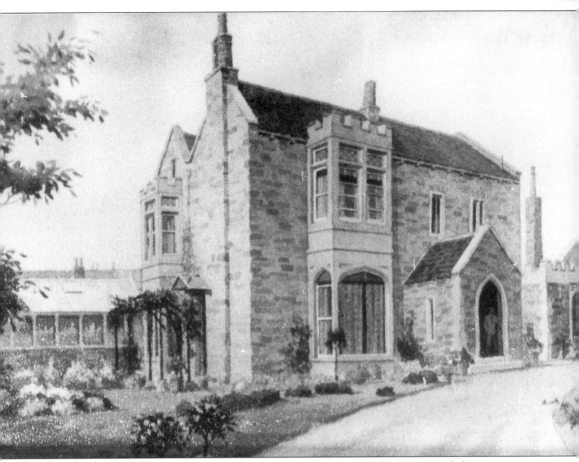

Tudor Lodge, an eighteenth-century farmhouse, was demolished in 1963 and the site is now occupied by Nos 247–265 Ashley Down Road. It is pictured here c. 1914. For some years the Jeffrey family lived there. Peter Jeffrey became a well-known actor, and is frequently seen on television. The house was used as a home for refugees prior to its demolition.

Sefton Park Road, *c.* 1925. An early view before the motor car became a common feature of everyday life. The playwright Christopher Fry, who wrote *The Lady's Not for Burning*, lived at No 78.

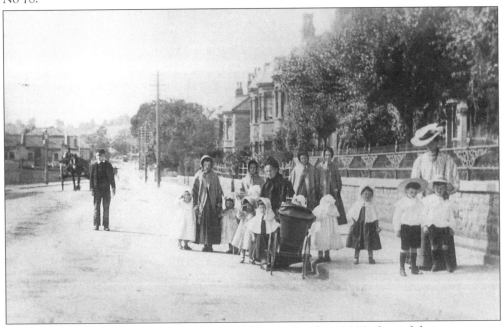

A view of Ashley Down Road near the top of Station Road, *c.* 1900. One of the entrances to the City of Bristol College (formerly Muller's Orphan Houses) is on the opposite side of the road, and has become famous as Holby General Hospital's entrance in *Casualty*, the BBC drama series filmed in Bristol.

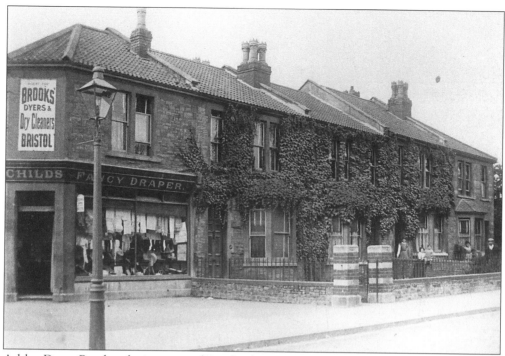

Ashley Down Road at the junction of Brynland Avenue, c. 1914. The shop on the corner was for many years a hardware store, and is now occupied by the William Hill bookmaker's.

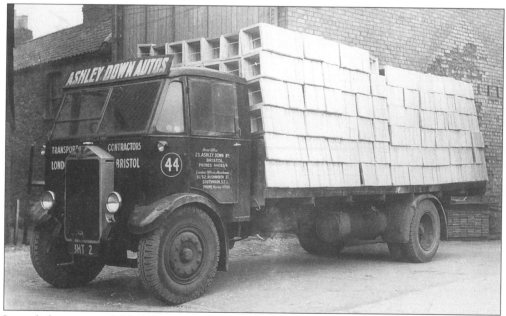

Lorry belonging to Ashley Down Autos, at No 23 Ashley Down Road, which was their head office c. 1950. They were haulage contractors plying between Bristol and London and had a fleet of lorries.

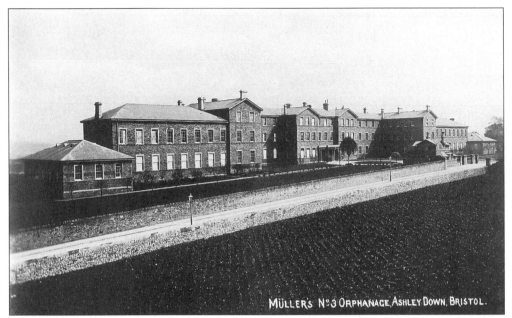

Muller's No 3 Orphanage, Ashley Down, *c.* 1890. Built in 1862, these premises are now part of the City of Bristol College. Behind this building a spring rises which once supplied water to the centre of Bristol at the Quay pipe. It ran down Ashley Hill, through Baptist Mills, Newfoundland Road, and The Horsefair.

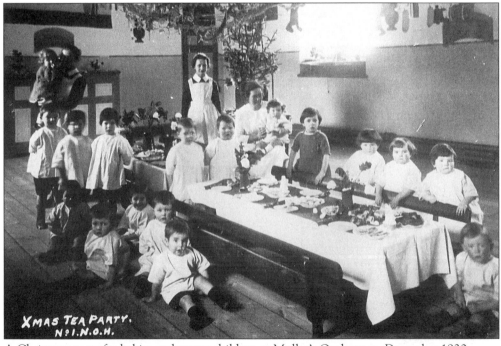

A Christmas party for babies and young children at Muller's Orphanage, December 1930.

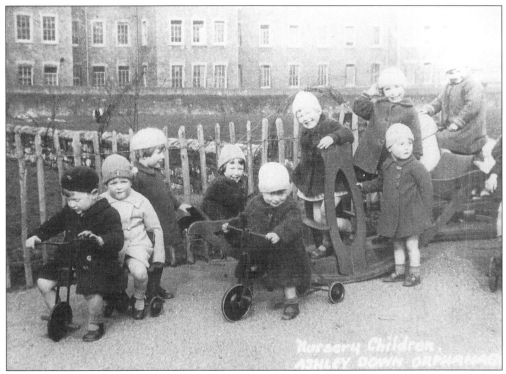

Children playing in the grounds of Muller's Orphanage, *c.* 1925.

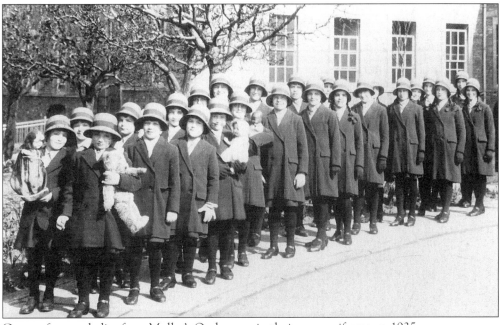

Group of young ladies from Muller's Orphanage in their new uniforms, *c.* 1935.

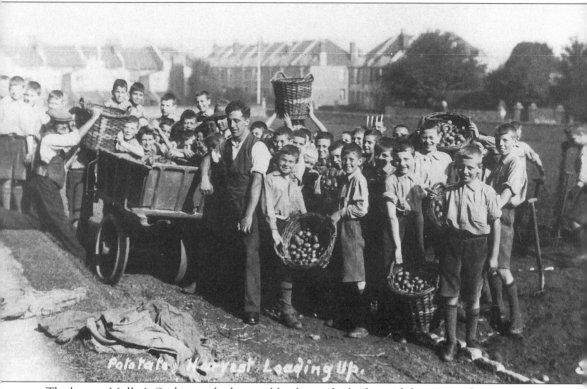

Potatos Harvest Loading Up.

The boys at Muller's Orphanage had vegetable plots to look after and the picture shows a potato harvest *c.* 1925.

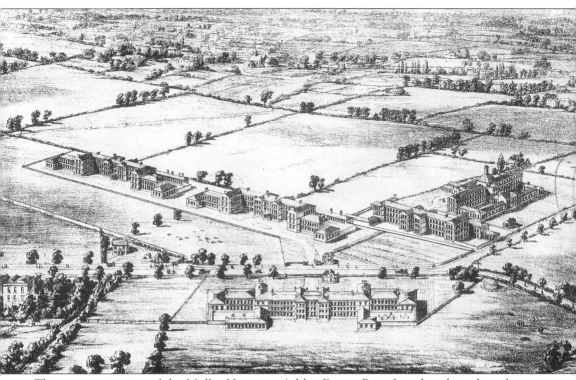

This panoramic view of the Muller Homes at Ashley Down, Bristol, is thought to have been sketched about 1880 from a captive balloon, tethered at the back of what is now Muller House. By inspiring public subscriptions through his charitable example Dr George Müller raised money for these buildings which were built between 1849 and 1870 on the Ashley Down site from local stone quarried at Fishponds. Two large gifts bought seven acres for £840. By May 1886, nearly 7,300 children had passed through Müller's care. Once a year the children crossed what is now Muller Road in one long crocodile on their way to a picnic at Purdown.

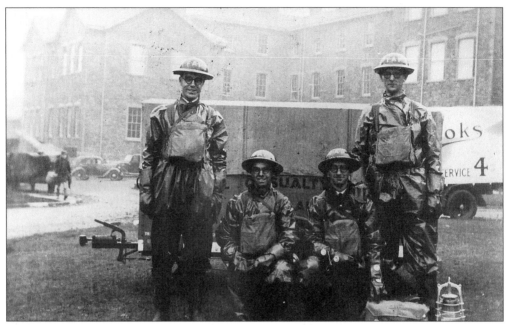

The winning team for the 'All Bristol First Aid Competition', November 1942.

A group of young ladies posing by W.D. & H.O. Wills's van at Muller's Orphanage, late 1930s.

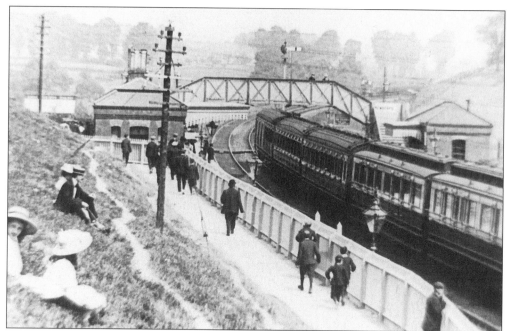

Ashley Hill station with schoolchildren seated on the embankment, *c.* 1905. Generations of youngsters have seated themselves above the station and trainspotted steam-trains belonging to the Bulldog, Castle, Hall, and King classes with *King George V* especially remembered. Sometimes two engines were required to pull a train up the incline from Stapleton Road station.

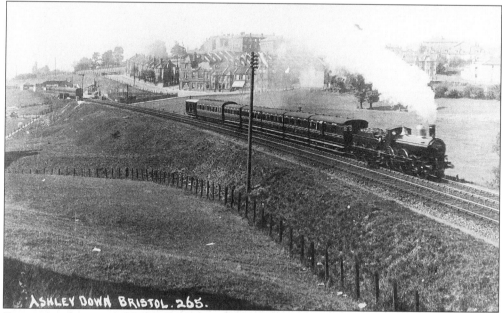

Steam-train leaving Ashley Hill station, *c.* 1890. The station was opened in 1864 on the new route to South Wales via New Passage Ferry, although it was rebuilt when the number of tracks were increased in the 1930s. It enjoyed a good service at that period, including trains on the route to Severn Beach via Pilning and back via Avonmouth.

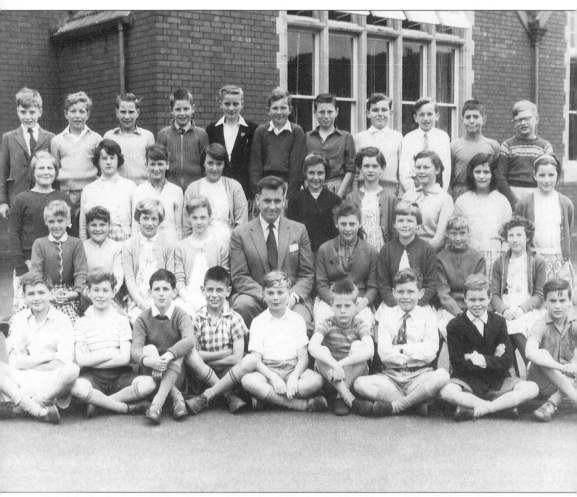

Mr May's class at Ashley Down School, 1960–61. Ashley Down School, like Bishop Road School, came into being because existing local schools were unable to cope with the large increase in pupils due to the development of housing in the area. The boys' school building was in Downend Road and the girls' and infants' schools were in Olveston Road.

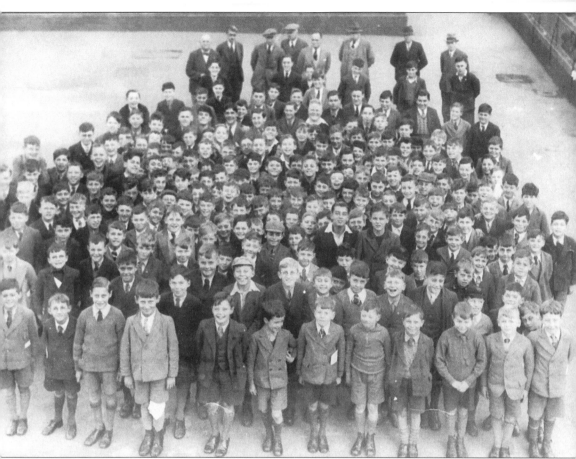

Boys in the playground of Ashley Down School, c. 1935, when Wilfred Gay was the headmaster. The school had an excellent reputation for sport, especially rugby and boxing.

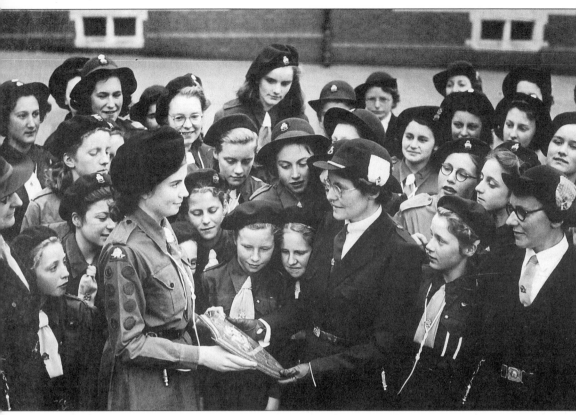

Mrs Robert Bernays, County Commissioner for Bristol, presents the winners' trophy to Patrol Leader Sheila Harris of the 43a (Berkeley Road) Guide Company at the Girl Guide Association regional drill competition which took place at Ashley Down School in 1947. Guides from other companies, including St Michael and All Angels and Horfield Methodist Church, are also pictured. District Commissioner Miss G.G. Clement is on front left of picture. Note the new berets which had just been introduced – Barbara Brace, captain of the 43a Guides had issued them to her company just before the competition. Reg Hughes, father of two of the guides, had spent time putting the 43a Company through their paces. The competition was judged by Miss Phyllis West, commissioner, front right. The divisional commissioner at that time was Muriel Smith, wife of the rector of Horfield Parish Church.

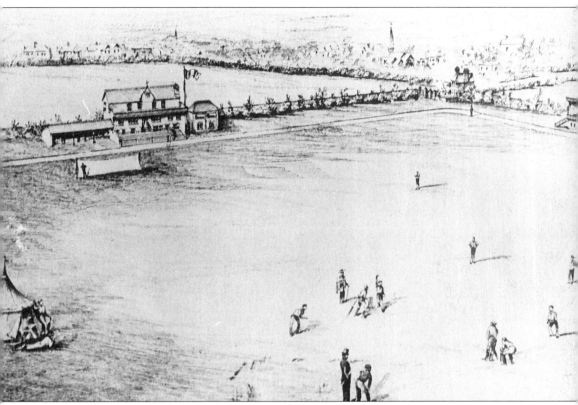

The County Ground, Nevil Road, *c.* 1890. Gloucestershire County Cricket Club, played their first matches on Durdham Down and later, so they could charge for admission, at Clifton College. The ground, comprising 25 acres at the end of Nevil Road, was purchased in 1888 for £6,500 and the first county match took place in 1889. In the picture the spires of David Thomas Congregational Church consecrated in 1881 (left background), and St Michael and All Angels consecrated in 1862 (centre background) can be seen. The County Ground Hotel, now The Sportsman, catered for the crowds who came to see the legendary W.G. Grace in action. The ground has been used in the past by Fry's Sports Club, local schools and by the police as a venue for their sports days. A cycle track used to encircle the ground. Royal visitors to the ground have included the Prince of Wales (later King Edward VIII) on the 10 June 1921, and more recently the late Diana, Princess of Wales on 11 April 1986 – she was Gloucestershire CCC's patron from 1985 to 1996.

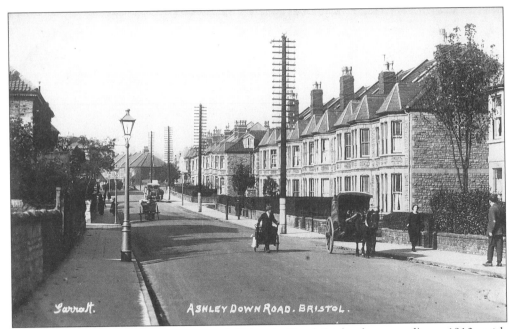

Ashley Down Road at the junction of Talgarth Road (right foreground), c. 1910, with Kennington Avenue on left and Ralph Road just left of centre. Horse-drawn vehicles and hand-carts predominate.

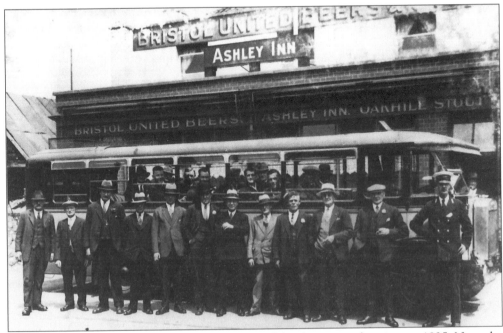

The Ashley Inn with a coach party about to set off for their annual outing, c. 1925. Note the corrugated iron shed to the left of the picture where Gillam's saw mills were situated.

Four

St Andrews

This district takes its name from St Andrew's Road which leads up from Montpelier, where St Andrew's Church and Vicarage were situated. The church was built in 1845 and demolished in 1969.

St Andrew's Park is the beautiful centrepiece for the surrounding large houses. It was opened on 1 May 1895 on a site donated by Mr Derham of Burghley Road and cost £8,500. It still has a bowling green, but its bandstand was removed some years ago. The people who moved into this area tended to be professional classes: doctors, lawyers, bankers, and teachers.

During the Second World War several bombs were dropped on the bowling green and near the sundial. A barrage balloon was sited on the park and in late 1941 a bomber from a Polish squadron became entangled in the balloon cables and crashed near St Bartholomew's Church. A girl from Maurice Road helped rescue some of the crew but not all survived.

Prior to the war the park was surrounded by railings which were removed to provide raw material for munitions. Air-raid shelters were constructed below ground to serve as refuges for the local population.

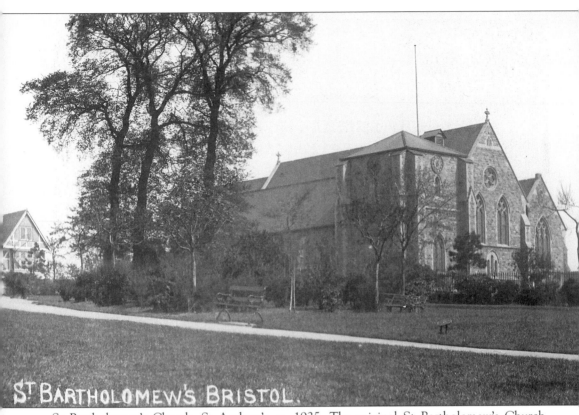

St BARTHOLOMEW'S BRISTOL.

St Bartholomew's Church, St Andrew's, c. 1925. The original St Bartholomew's Church, Union Street, was consecrated in 1861. It became almost wholly enclosed by the rapid extension of the cocoa manufactories of Messrs Fry & Sons and the directors gave a large sum for the site which was needed for further expansion. The memorial stone of the new church, designed by W. Bassett-Smith, was laid on 25 July 1893 and the building was consecrated on 10 May 1894. The royal assent had been given in 1892 to a bill which was to transfer the endowments and schools of St Bartholomew's to a new district partially formed out of St Andrew's, Montpelier.

Opposite: St Andrew's Park, c. 1910. On the occasion of the coronation of King George V in 1911 every pathway and flower bed was edged with coloured-glass fairy lights containing candles.

118

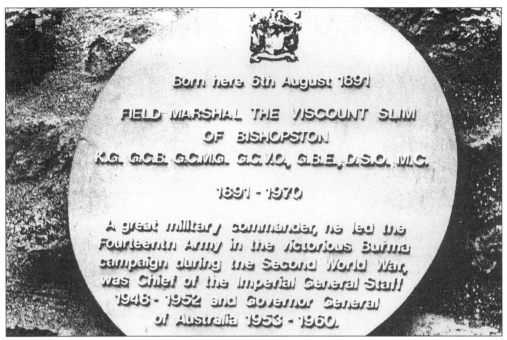

Born here 5th August 1891

FIELD MARSHAL THE VISCOUNT SLIM
OF BISHOPSTON
K.G. G.C.B. G.C.M.G. G.C.V.O., G.B.E., D.S.O. M.C.

1891 - 1970

A great military commander, he led the
Fourteenth Army in the victorious Burma
campaign during the Second World War,
was Chief of the Imperial General Staff
1948 - 1952 and Governor General
of Australia 1953 - 1960.

Bristol should be proud of Field Marshal William Joseph Slim (1st Viscount Slim of Yarralumla and Bishopston) who was born here in 1891 and went on to be regarded as one of the most popular commanders ever. He had a warm, magnetic personality and engaging human quality not always associated with top military leaders. His character affected his soldiers in such a way that they would gladly die for him. Slim became commander of the 14th Army (the 'forgotten army') in Burma in 1943, and after successful operations against the Japanese he became supreme allied commander in south-east Asia. In 1948 he became chief of the imperial general staff and then from 1953–60 was governor-general of Australia. Slim lived his early life in Bishopston, and a plaque adorns the house at No 72 Belmont Road. He was fond of cricket and spent his schoolboy years watching W.G. Grace in action for Gloucestershire at the nearby County Ground in Nevil Road. He died in 1970 at the age of 79.

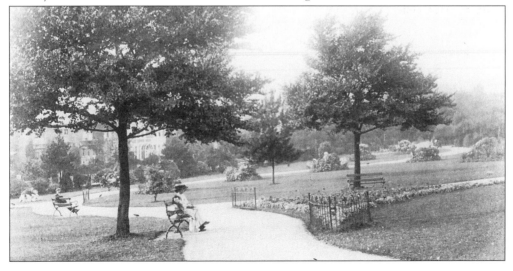

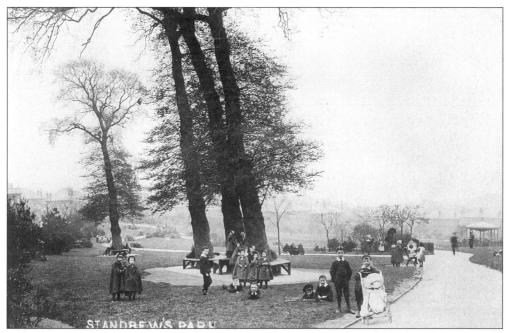

St Andrew's Park, *c.* 1915, with the bandstand in the background on the right. This was a very popular feature of the park and became a shelter and meeting place for many young people. The children in the foreground are from Müller's Orphanage.

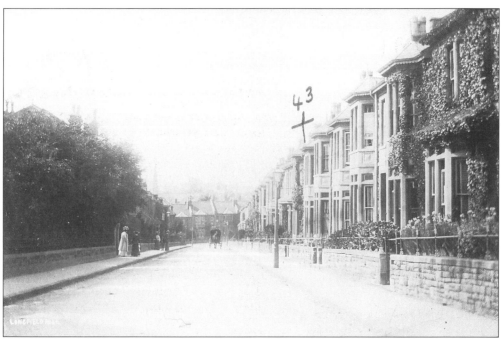

Longfield Road, pictured on a postcard sent in 1906 by the occupant of No 43.

Jill Baily with William Scholar and his family enjoying a visit to the park, June 1932. This picture is representative of the generations of children and their parents who have walked and played in the park.

Wartime issue of instructions on use of a static-water tank for fire-fighting.

STATIC DRINKING WATER

SITE 213 K. 2. Central St Andrew's Park

Emergency Drinking Water 2 x 100 Gal. tanks.

Instructions in use of unit

1. Unit will go into action only on receipt of instructions from D.H.Q.

2. Swill out with 2" Water followed out by cleansing with 2" of Water + test tube of Chloros
Or Test tube of Chloros to bottom of tank, add Water to depth of 3" wash thoroughly sides & bottom, drain river out with clean Water

3. Standpipe Water from carts

4. Clean each Morning during use

5. no need to boil water

6. Water carts should call regularly on rotation

7. Log book - fill up times unit in use

8. Radius of 1/4 mile

9. 3 Posters & arrows Leopold - Chesterfield Rd
 " Effingham
 Melita - Sommerville

10. Water for drinking purposes only.

W.V.S. helpers:-

Mrs Gregory 8. Leopold Rd Mrs Hoyes 23 Nutt Rd
 Tole 102 St Cromwell Rd Smith 20 " ?
 Spong 95 " Cooper 40 Windsor
 Tucker 13 Burghley
 Collins 6 Winsor

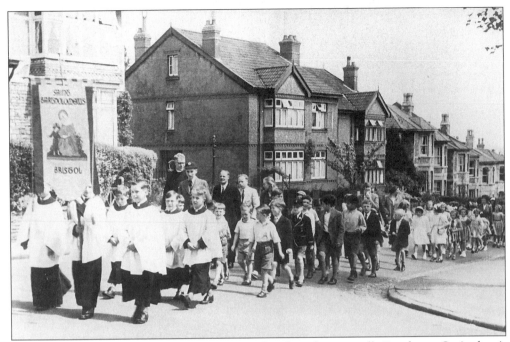

Whit Sunday procession of St Bartholomew's Church in Sommerville Road near St Andrew's Park, c. 1955.

Mr and Mrs Ainslie Lovell posing by the sundial in 1930. This was situated near the lower boundary of the park adjacent to Effingham Road.

St Andrew's Park Bowling Club, *c*. 1950.

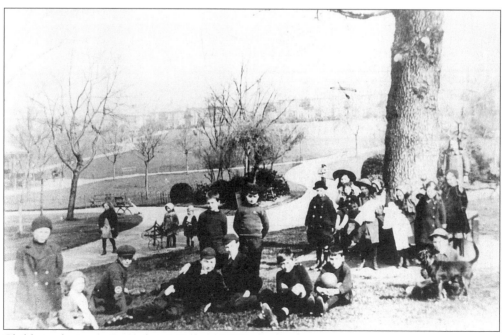

Children playing in St Andrew's Park, *c*. 1910.

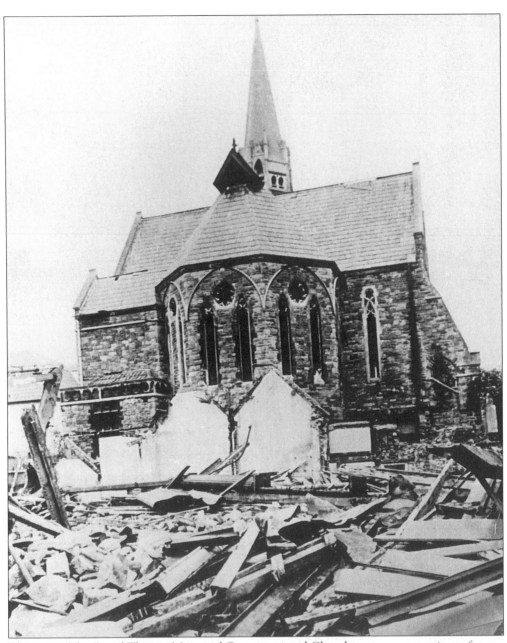

The spire of the David Thomas Memorial Congregational Church was a very prominent feature of the landscape. The foundation stone of the church was laid by Samuel Morley MP, on 3 October 1879. It was designed by Stuart Colman and opened in 1881 as a memorial to Rev David Thomas. He was born at Merthyr Tydfil in 1811 and was a pastor of Zion Chapel in Bedminster until he became ill and went to South America for his health. On his return to England he was invited to preach at Highbury Chapel, Cotham as a supply minister. In 1844 he assumed permanent pastorship at Highbury and remained there until his death in 1875 at the age of 64. It was his wish that a chapel be built in the Bishopston area. The church was demolished after planning permission was obtained in 1984 for conversion to housing for the elderly, and the work of building was completed by the end of 1987.

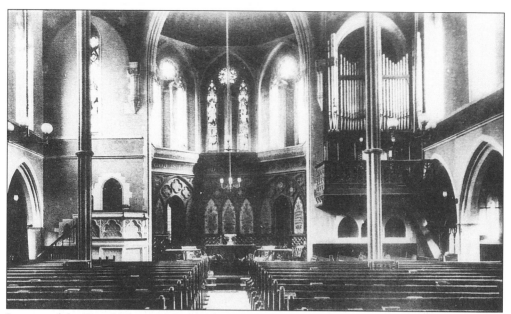

Interior of the David Thomas Memorial Congregational Church, *c.* 1930.

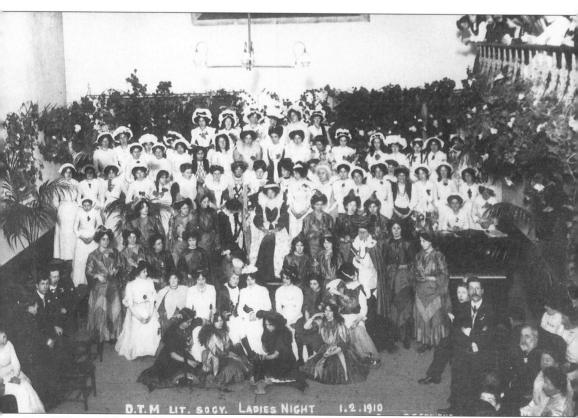

D.T.M LIT. SOCY. LADIES NIGHT 1.2.1910

David Thomas Memorial Literary Society ladies' night, 1 February 1910.

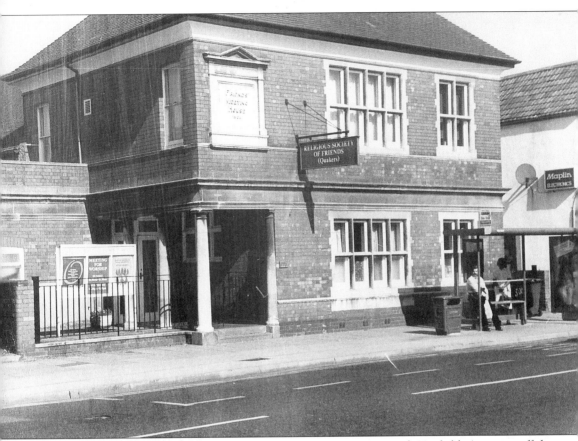

The Friends (Quakers') Meeting House at No 300 Gloucester Road, Horfield. A stream off the Common, believed to come from the direction of Quab Farm, runs beneath the premises and part of it may be seen in a culvert in the cellar.

Bishopston, Horfield & Ashley Down Local History Society

The Society celebrated its tenth anniversary in October 1997, having initially been formed at an inaugural meeting held at Horfield Library on 21 October 1987. The original committee included Penny Jetzer as chairman and Brian Amesbury as treasurer, both of whom were on the editorial committee for this book. Other officers appointed at the meeting were the late Charles Standrick as vice-chairman, and Mr and Mrs J. Whyatt as joint secretaries. The rest of the committee were Mrs Dagg, the late Mrs Norah Gover, Mr Chidgey, and Mrs Brenda Hardingham, a Bristol City Council Blue Badge Tourist Guide. The present elected officers are: Richard Webber (chairman); Ken Forward (treasurer); John Davis (secretary); Gilbert Begbie (social secretary).

The Society normally meets on the third Tuesday of each month at the Society of Friends Quakers' Hall at 300 Gloucester Road, Bishopston. Since its foundation it has gone from strength to strength and the present membership stands at around one hundred. There is a full and varied programme of lectures, talks and slide shows each month. There are also outings of historical interest.

If any further information is required, write to the chairman, Richard Webber, at 150 Downend Road, Horfield, Bristol BS7 9PX or telephone him on (0117) 951 9173.

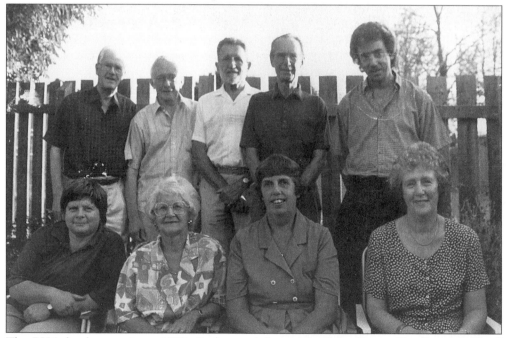

The BHA book committee, 1997. Back row, left to right: John Davis, Ken Forward, Geoff Rosling, Brian Amesbury, Richard Webber. Front row: Penny Jetzer, Pat Smith, Mollie Snart, Diana Davis.

Parson Goldney's Journey to Horfield
(A poor little village in Gloucestershire, near Bristol), 1747

The clock struck eight, the morning clear'd
The choc'late drank, the coach appear'd,
To Horfield bound; a dirty road.
A stomach sick, with hyppish load;
A jumbling coach, a grumbling wife,
With two friends more perplex'd in life.
At length arriv'd at Horfield-green,
No church-bell, heard, no mortal seen,
A place as wild, as cold, as bleak
As Newfoundland or Derby-Peak;
A village void of bit or scrip
To stop the vicar's fretful hyp;
A church yard sod in watry swamp,
A puny church, a surplice damp;
The reading-desk extremely cold,
A pulpit dusty, weak and old;
A prayer-book of dull print letter,
A Bible rather worse than better;
A congregation very small.
Made but of few poor souls in all
Three ancient dames with wither'd faces
Fell fast asleep in lower places;
Two grey-hair'd dons with glove on pate
Sat just above in nodding state.
One maiden fair with yellow knot,
The only primrose on the spot:
The rest were chiefly farmers' men
That star'd and list'ned now and then.
The beardful clerk that sings or says,
Who's poorly versed in musick-lays,
A psalm uprear'd in jangling notes,
Contriv'd for sol-fa's growling throats,
In broken tune, now in, now out,
'Twas all confus'd, like babel's rout.
Then came the sermon, long and dull,
Adapted right to Clod-pate's skull,

Some snor'd, some gap'd, one sober lad
Beneath his arm a Bible had;
This book-learn'd youth had wit enough
To turn to doctor's scripture proof;
He doubled down the quoted place,
And sat demure with awkward face.
The sermon done, no dinner near,
A mile at least to cup and chear;
Church-warden hog not seen at church,
Left hungry parson in the lurch;
The weather chang'd to snow and sleet
Made chatt'ring teeth and chilly feet.
The youth look'd blue, the lady pale,
For want of something to regale.
Driving at length thro' miry ground,
We reach'd the Ostrich* on the down.
Where, glorious sight! by great good luck,
Just as the stomach-hour had struck,
A loin of veal in lordly dish,
And kail and bacon, all I wish,
Allay'd the grumblings of the day,
And rais'd our spirits up to gay:
We there sat down content and snug,
With wine, and ale and cyder mug;
Yea, cups of tea, the good wife's treat,
Appear'd to make the scene compleat.
Nature refresh'd in cheerful way,
We drank and pledg'd and call'd to pay.
Then coachman wheel'd to Clifton round.
And brought us home all safe and sound.

Horfield farewel; thou starving soil,
Not worth a preacher's charge and toil.
To ride thro' dirt thro' cold with hunger keen,
To teach sad swine on ignoramus green.

*A Sign of a Publick House on the Down.